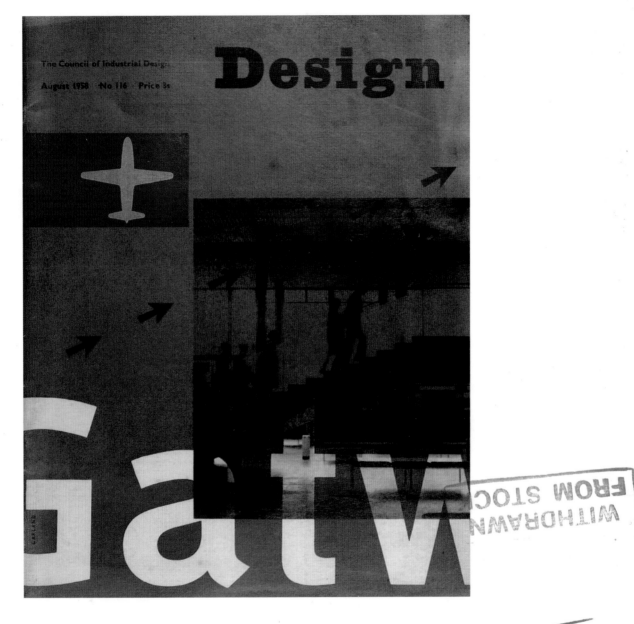

MAGAZINE COVERS

FUTURE

SCIENCE FICTION *stories*

PRICE IN
1/-
GT. BRITAIN

DEVIL'S CARGO
by Tom Wilson

GO TO THE ANT
by Walter Kubilius

FOUNTAIN OF DEATH
by Joseph Farrell

ALL STORIES NEW
NO REPRINTS

A
DOUBLE-ACTION
MAGAZINE

First published in Great Britain in 2003
by Mitchell Beazley, an imprint of
Octopus Publishing Group Ltd,
2–4 Heron Quays, London E14 4JP

First published in paperback 2006

Commissioning Editor: Mark Fletcher
Managing Editor: Hannah Barnes-Murphy
Executive Art Editor: Auberon Hedgecoe
Copy Editor: Colette Campbell
Designed by Fiona Pike
Picture Research: Juliet Duff
Production: Gary Hayes
Indexer: Ann Parry

ISBN-13: 9 781 84533 239 6

ISBN-10: 1 84533 239 3

A CIP record for this book is available from the British Library

Set in Skia

Produced by Toppan Printing Co., (HK) Ltd
Printed and bound in China

DAVID CROWLEY

MAGAZINE COVERS

MITCHELL BEAZLEY

CONTENTS

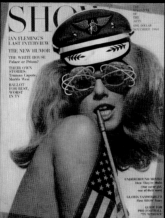

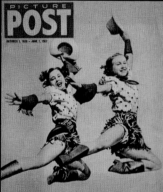

TIME

THE WEEKLY NEWSMAGAZINE

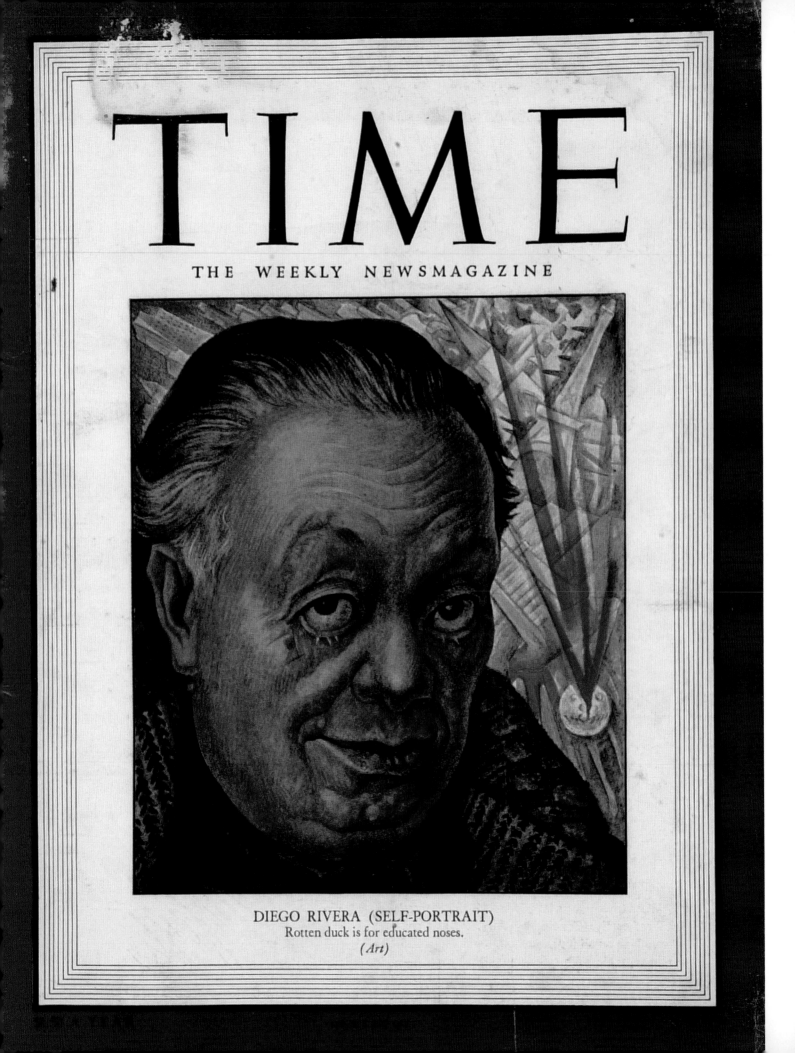

DIEGO RIVERA (SELF-PORTRAIT)
Rotten duck is for educated noses.
(Art)

INTRODUCTION

William Randolph Hearst, the multi-millionaire publisher of magazines like *Cosmopolitan* and *Harper's Bazaar,* whose life inspired the film *Citizen Kane,* held the view that there was not much to the art of the magazine cover. All that was needed, he was reported to have said in the 1930s, was a picture of a pretty girl and a doe-eyed dog. Slushy sentiment was enough to make the reader part with their money.

Few share his view, then or now. Most art directors, photographers and artists have seized the cover of the magazine as a public stage on which to project their creativity or views. This book illustrates some remarkable and arresting designs that have captured the drama of the age, or even offered new ways of seeing the world. The magazine cover, for those who appear on them, can also act as a marker of achievement. Depiction on the front of the American news weekly *Time* has long been recognized as an accolade. Even those lampooned by the British satirical magazine *Private Eye* often acknowledge the topsy-turvy satisfaction of this kind of public attention.

"The cover," according to cultural theorist Ellen McCracken, "serves not to label only the magazine but the consumer who possesses it." Covers try to connect with our values, dreams and needs. It is perhaps not surprising then that they aspire to take on human form; "speaking" to us with their coverlines, adopting personas and characters in their titles and staring out at us, albeit through the eyes of the "headshot". The dominance of the image of the face and the body on these ephemeral products is incontestable. Often it seems as if our desires – sometimes deep-seated ones – are being aroused, whereas at other times it is as if we hope to find ourselves in the magazine's glossy pages. *Nova*, the celebrated women's magazine of the 1960s, claimed to have discovered a new kind of woman "with her eyes wide open and a mind of her own". The new magazine was to be as "up-to-the-minute and arresting" as its readers.

This meeting of interests is often – though not inevitably – driven by the need to sell. The cover promotes a product, the magazine itself. And magazines deliver readers to advertisers. Commercial pressures are not equally distributed in the world of magazine publishing. Where competition is greatest – most notably in the world of women's magazines – the pressure on the cover is greatest. It can make the sale in a market where readers often have little brand loyalty. For this reason, tried and tested formulae win over innovation when the "cover conference" between the art director, editor, and publisher, takes place. Market research often leads the way. David Bailey, the prominent British photographer, described the influence of psychologists and marketeers at *Vogue* in the 1960s: "On the same day, six photographers shot a cover ... six photographs would be put up on the wall and one was chosen. The light was always on the model's right and her eyes were looking towards it, to draw the viewer to the type. A psychoanalyst called Doc looked at the covers, and if he did not like one it just did not go on." Conventions – many more than 40 years old – prevail about the kind of faces that are "right" (young and conventionally beautiful) and about the interrogative style and busy layout of the coverlines from which covers are made.

But not all fields of magazine publishing are so cautious. Where magazines command loyal readers or when a title wants to mark itself out against the opposition, imagination has had freer reign. Paradoxically, the challenge of representing the abstract and often invisible world of cutting-edge science or the glamourless world of industry has encouraged great cover art.

While other cultural products – like vinyl records and video cassettes – come and go, the magazine has enjoyed more than a century of steady success. A copy of *Vogue* or *Vanity Fair* from the early years of the 20th century stands comparison with its counterpart today. The thick spines, glossy paper and warm-toned colours of these upmarket titles, as well as their emphasis on fashion, celebrity or current affairs, remain consistent features of modern periodical publishing. Magazine publishers have attempted to break convention to gain market advantage. Occasionally an art director has tried the landscape format, but confusion about which end was up on the news-stand usually had the effect of changing his or her mind.

Despite the consistency of the magazine format, there have been significant changes in the way that magazines have been produced. Colour printing – once reserved for the cover – became much more affordable from the 1950s. Developments in other fields of technology played their part too. The refinement of small

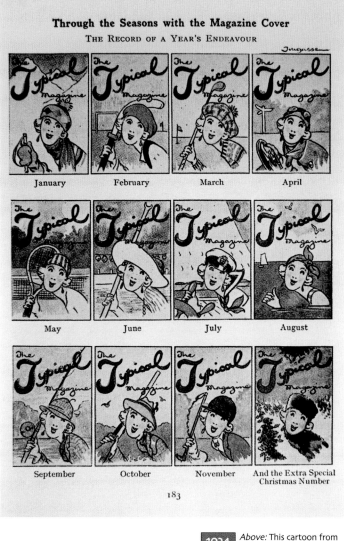

1934 *Above:* This cartoon from the pages of leading British satirical magazine *Punch* depicted the changes in the cover of the "*Typical*" magazine over the course of a year.

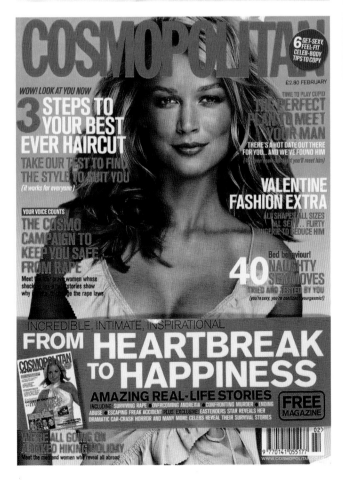

1992 *Left: New Scientist* regularly featured cutting-edge illustration on its covers in the 1990s. This collage, announcing an article on space probes, was produced by Andrew Kingham from discarded tin.

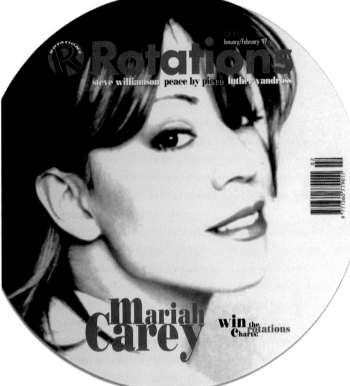

2003 *Left:* With its beautiful cover model, busy type and free gift, *Cosmopolitan* reflects the dominant approach to magazine cover design in the highly competitive field of women's magazine publishing.

1997 *Above: Rotations*, a magazine celebrating soul music, was a short-lived venture. Even though it adopted this circular format, *Rotations* had to be distributed in a plastic bag supported with a rectangular backing card.

LIFE

APRIL 9, 1945 **10** CENTS

YEARLY SUBSCRIPTION $4.50

REG. U. S. PAT. OFF.

1945 *Opposite:* As the conflict with Japan drew to a climax towards the end of the Second World War, W Eugene Smith, a celebrated photojournalist, recorded the terrible destruction of the battle for Iwo Jima, an island in the Pacific. His photograph captures the overwhelming shower of rock and debris thrown up by an exploding shell and the recoil of the Marines in the foreground.

1918 *Below: The Sphere*, a family magazine read by the middle classes, was an unwavering supporter of the First World War. Representing the conflict, it often relied on hand-rendered images of valour or authority. The illustrator's brush or the pencil could heighten the heroic dimensions of the conflict in ways that the large format camera could not. This sympathetic portrait of General Foch was drawn by S Ugo.

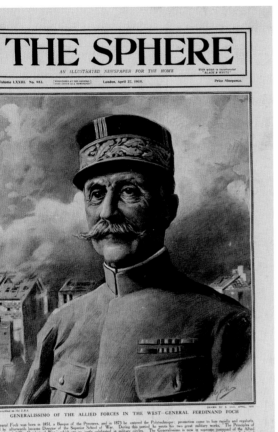

THE SPHERE
AN ILLUSTRATED NEWSPAPER FOR THE HOME

Volume LXXIII. No. 953. London, April 27, 1918. Price Ninepence.

GENERALISSIMO OF THE ALLIED FORCES IN THE WEST—GENERAL FERDINAND FOCH

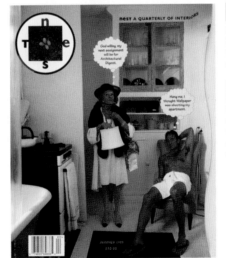

2003 *Above:* Like most titles, *Q*, a glossy that offers in-depth coverage of rock music, has a website that both promotes the magazine and offers up-to-date coverage of events.

1999 *Left:* This gently ironic cover of the American interiors magazine *Nest* has a die-cut profile. The device is repeated inside in the form of rococo graphic "frames" around many of the photographs.

hand-held cameras in the 1920s, for instance, meant that the explosive drama of war could be captured photographically for the first time. Photojournalism of the kind that appeared in magazines like *Life* was a new way of recording the world. Our capacity to know its marvellous and tragic faces was much enhanced by the small camera and photogravure printing.

Commentators, charting the rise of other media, have repeatedly prophesied the magazine's demise. The success of television in the 1950s and 1960s, it was said, would kill off popular magazines. After all, who would want inky paper when they could get their entertainment and news pumped into their homes? In the early 1990s another generation of soothsayers predicted that the

application of digital technology would kill off print. All our information needs would be delivered through portable screens. This too has proved to be an exaggerated prediction. In fact, the appearance of new media has often stimulated innovation in magazine publishing. For instance, television may have hastened the decline of mass readership titles like *Picture Post* in Britain in the mid-1950s, but it also stimulated the launch of new glossies to satisfy public desires to get behind the scenes and into the lives of those who appear on the television. Most magazines today are supplemented by websites that offer the readers up-to-the-minute information and the chance for dialogue. Behind their shiny and seductive covers, magazines show few signs of disappearing.

domus

architettura arredamento arte

344 luglio 1958

THE ART OF ART AND DESIGN MAGAZINES

To defamiliarize the commonplace, to see it as if it were for the first time is the artist's goal.

Paul Rand, *A Designer's Art*, 1985.

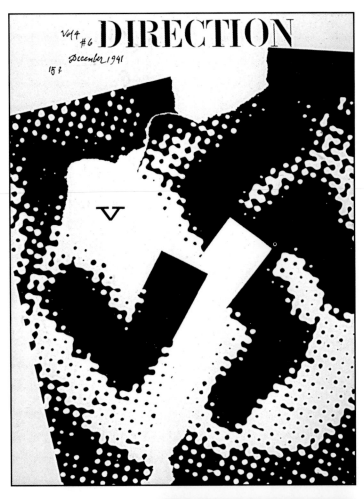

Vol 4 #6
December 1941
15 ₮

DIRECTION

V

1958 *Previous page:* This cover of leading design magazine *Domus* features an abstract image by American photographer William Klein.

1941 *Above: Direction*, a left-leaning cultural magazine, was designed by Paul Rand between 1938 and 1945. He was to become one of America's leading graphic designers. This cover prophesied the destruction of Nazism in the form of a shattered swastika.

1997 *Right:* Unlike most art magazines which reproduce the work of well known figures in the art world, *Frieze* often presents the reader with unexpected crops of works of art or surprising images. This cover features a detail from the inner sleeve of Led Zeppelin's album, "Presence", designed by Hipgnosis twenty years earlier.

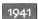
1962 *Right:* German magazine *Gebrauchsgraphik* has had an influential role as a clearing house of international design thinking since the 1920s. This cover features the work of illustrator Walter Tafelmaier.

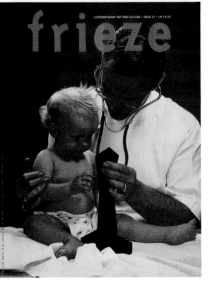

frieze

1933 *Opposite: Minotaure*, a highly refined magazine by the standards of many avant-garde products of the day, was first published by Albert Skira and Efstrathois Tériade as a voice-piece for dissident Surrealists, a movement renowned for its internecine struggles. The second issue featured Gaston-Louis Roux's design on the cover.

THE ART OF ART AND DESIGN MAGAZINES

Modern art and design has relied on the mass media in general, and the magazine in particular, since the beginning of the 20th century. Emergent art movements and publicity-conscious individuals have turned publisher to promote their ideas. The history of modern art and modern design has been punctuated by manifestos, often issued in small, irregularly produced magazines, while the activities of prominent artists and designers have often been reported on the pages of the mainstream press. In fact, one definition of the avant-garde places less emphasis on the nature of the actual work of art than on the modern artist's ability to work the media. One guaranteed way of getting a place in the pantheon of the avant-garde – as surrealist artists in the 1920s showed – was to court controversy. When a building, artwork or design could not travel easily, its image could. In one famous essay, the German writer Walter Benjamin argued that society's fascination with the "original" work of art would wither as the technology of reproduction was perfected. In many ways he was right: the work of art today is often produced with reproducibility in mind. He was also wrong: our appetite for original works of art – as witnessed by the central place of the gallery, monument and landmark on the tourist's itinerary – has been intensified by the art and design press.

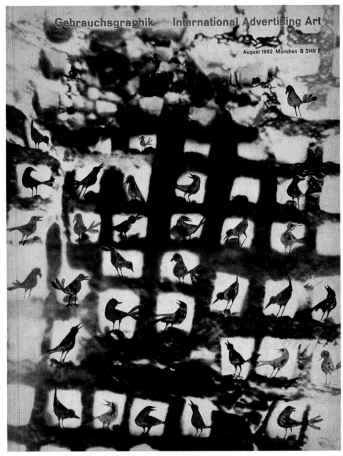

Gebrauchsgraphik International Advertising Art

August 1962 München B 3149 E

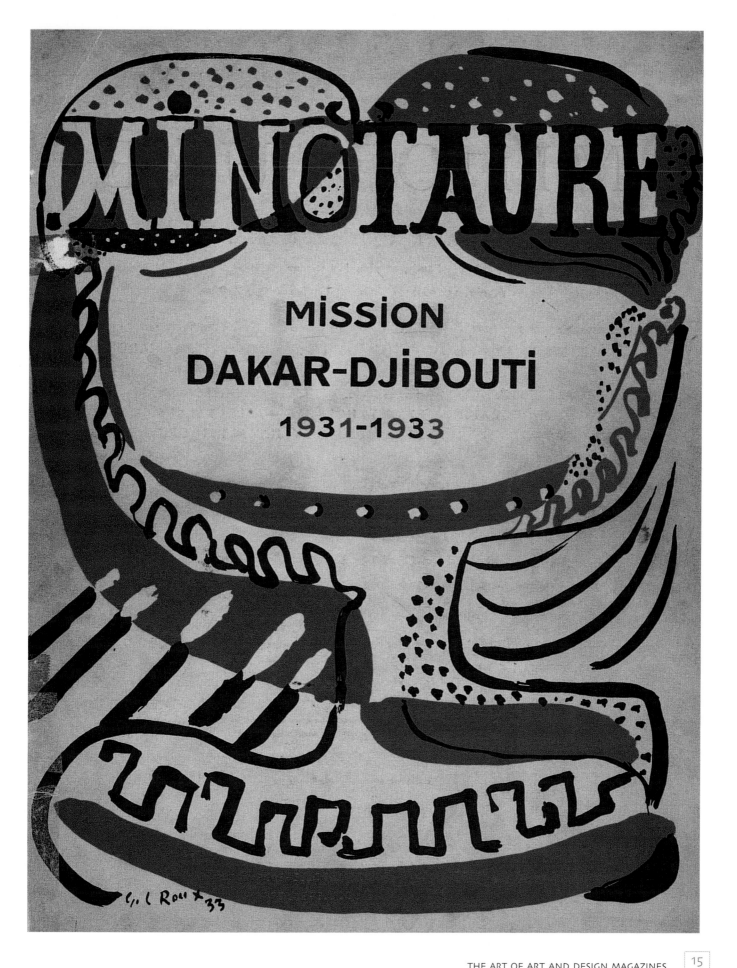

1895 *Right:* Will Bradley is often credited as the first art director in the United States for his work on *The Chap-Book* in the mid 1890s. This remarkable cover makes highly inventive use of repetition and bold graphic line.

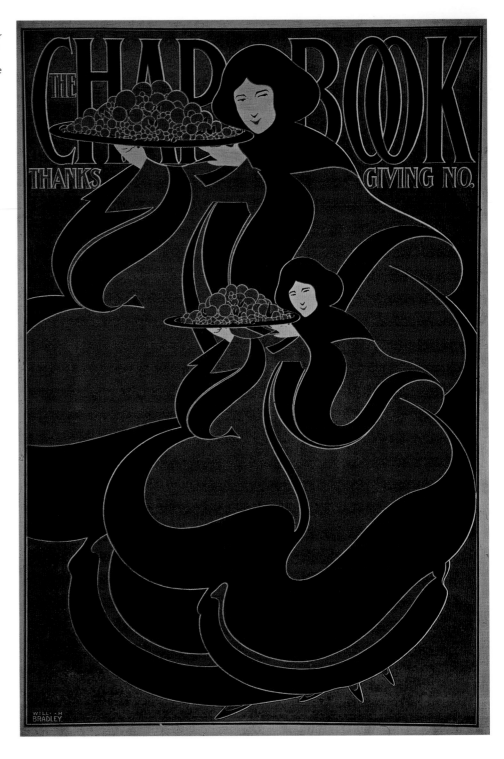

THE ART NOUVEAU JOURNAL

Although specialist art magazines were published widely throughout the second half of the 19th century, the 1890s saw a wave of new titles in Europe and the USA. Magazines like *Jugend* (Youth), published in Munich from 1896, and *Ver Sacrum* (Sacred Spring), which appeared in Vienna in 1898, not only made full use of new developments in chromo-lithographic and photomechanical printing processes that allowed colour and

photographs to fill the page, but they also invested great energy in what one editor called in 1903 "the struggle to be modern". Often closely connected to artistic movements or groups, these journals promoted symbolist and post-impressionist art and often issued biting critiques of bourgeois society. The favoured characteristics of much post-impressionist art – flat planes of vivid colour and heavy dark contours – were well suited to the print processes employed by these new magazines. Unlike many avant-garde movements of the early 20th century which

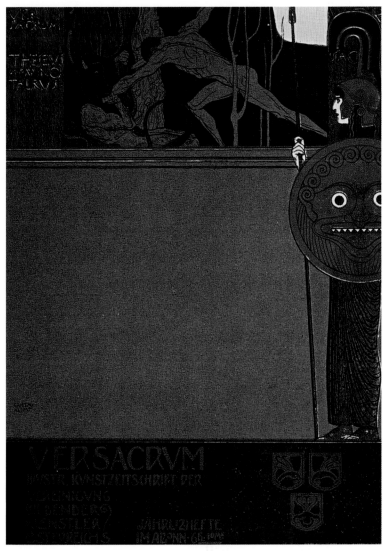

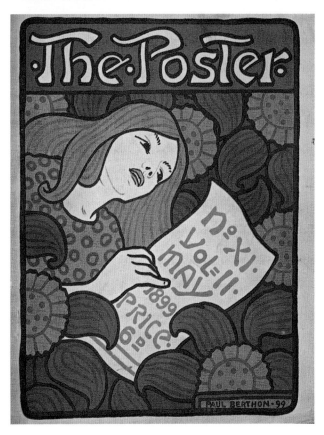

1898 *Above:* Painter Gustav Klimt designed this image as a poster to promote the first Secession exhibition in 1898 of works by artists who had broken away from the official art organisations in Vienna. Depicting Theseus and the Minotaur, it was an allegory for the struggle of art. It was adapted for the cover of *Ver Sacrum*, the Secessionists' journal.

1899 *Above right: Jugend* was first published by Georg Hirth in Munich in 1896 and lent its name to the movement known as Jugendstil (Style of Youth) in Germany. Hirth insisted that the pictures that appeared on the cover reflected the theme of youth, albeit often in symbolic and enigmatic ways.

1899 *Right: The Poster* was published to serve the fashion for collecting posters in Britain at the turn of the century. This cover is by French designer and decorative artist Paul Berthon, and combines the figure of a woman with plant motifs in a classic Art Nouveau design.

proclaimed their futurism, modernist artistic groups around 1900 often reworked themes and myths from the past. *The Chap-Book,* a progressive magazine published in Chicago which introduced the works of many members of the European avant-garde to the United States, took its title from a cheap and popular printed form of the 17th and 18th century. The artist-illustrators of *Ver Sacrum* magazine often drew out sexual and psychological undertones in their images taken from popular themes in classical mythology.

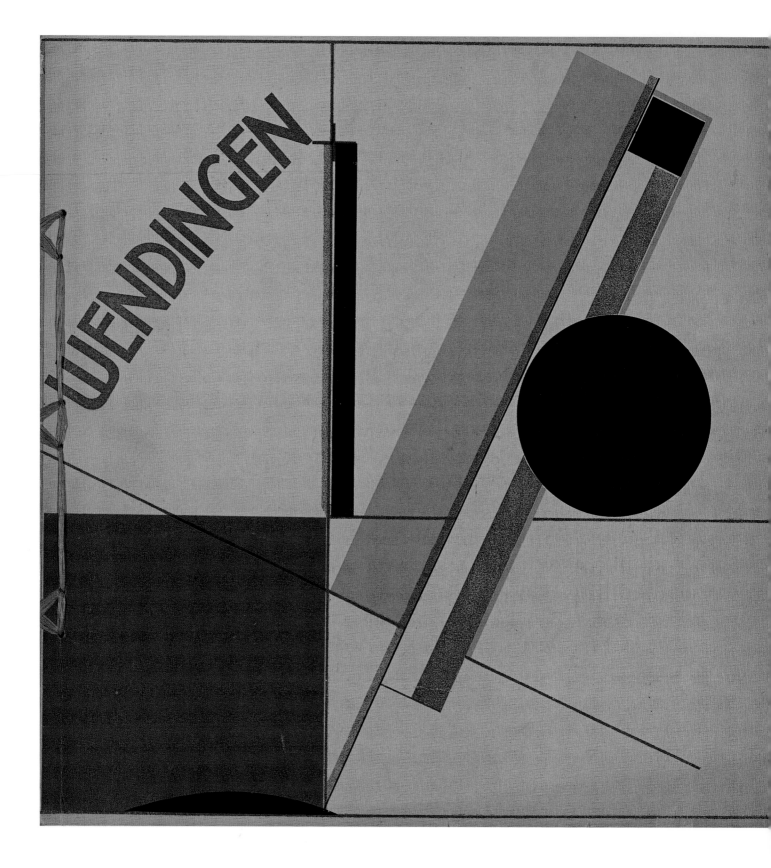

THE ART OF ART AND DESIGN MAGAZINES

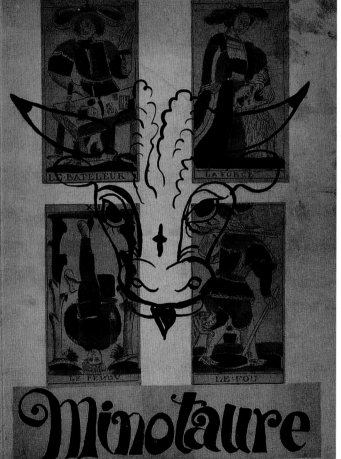

1933 *Above:* Each issue of *Minotaure*, a surrealist review published in eleven issues between 1933 and 1939, featured an image of the Minotaur by leading artists including Marcel Duchamp and Salvador Dalí. The third cover – depicting a minotaur overlaid onto tarot cards – was designed by André Derain.

AVANT-GARDE MAGAZINES

It is hard to imagine the phenomenon of the avant-garde – visionary cabals of artists or writers who set out to scandalize or change conservative society – without the magazine. For much of the 20th century, the magazine, alongside the exhibition, was the medium by which avant-garde groups spread their gospels and demonstrated their existence to the rest of the world. Art groups and entire art movements – such as Fluxus in the 1960s or Jugendstil around 1900 (see page 17) – have even taken their names from the titles of the magazines that promoted their work. Another characteristic feature of the modernist avant-garde has been its internationalism. Ideas and practices have been exchanged across borders by small numbers of artists on the pages of a magazine. *Wendingen,* a Dutch title published between 1918 and 1932, represented a wide range of avant-garde art and architecture from the Urals to the American mid-West. Internationalism has often been a matter of ideology rather than just opportunity. In the inter-war period for instance, artists rejected nationalism as a false creed that had plunged Europe into a destructive and divisive war.

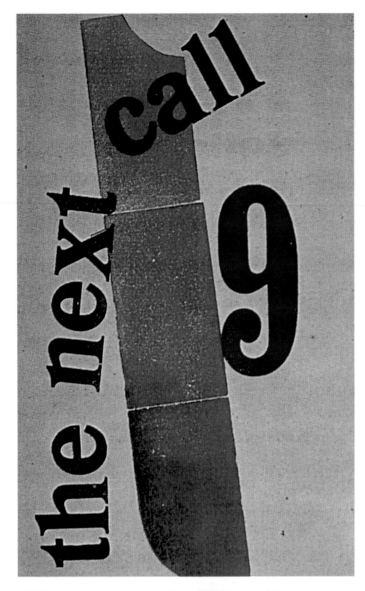

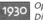1930 *Opposite:* This cover of
Die Neue Linie (designed by
Herbert Bayer) represents state-of-the-
art thinking about typography and
photography. Although the Modern
Movement's enthusiasm for the kind of
sans-serif, lower-case letterforms that
featured on the masthead were attacked
by the Nazis as being a threat to German
tradition, they continued to feature on
the cover of this popular magazine
through the 1930s.

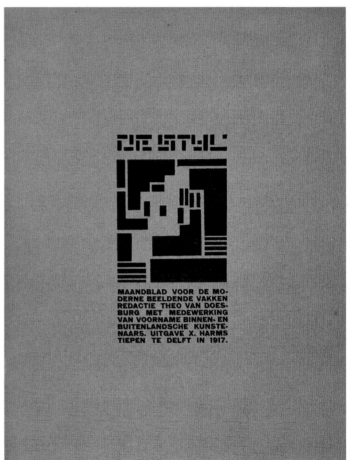

1926 *Above:* Dutch designer Hendrik
Werkman's magazine, *the next
call,* was the vehicle for his experiments
in handprinting. Using an old handpress
and found materials, Werkman broke
the conventions of typographic design
and layout.

1917 *Right: De Stijl,* an avant-garde
group formed in the
Netherlands in 1917, aimed to unite all
fields of art and design by the adoption
of a common style. Co-founder Theo
van Doesburg promoted a reductivist
and geometric aesthetic exemplified in
this cover design by Vilmos Huszar.

THE MODERN MOVEMENT IN GRAPHIC DESIGN

Many of those writing and thinking about graphic design believed
that, while technological developments were leading the way to
a new world, designers lacked the rigour and imagination of the
scientist or engineer. The challenge was to find new, rational
principles to free design from the weight of tradition. Bauhaus
School of Design teacher Laszlo Moholy-Nagy complained in 1925
that: "we do not even possess a typeface that is ... based on a
functional form of visual appearance without distortions and
curlicues". And, when photographs appeared in print, as he argued
in his book *Painting Photography Film,* they usually mimicked

"pictorial" styles of depiction favoured by the easel-painter. The
answer to these problems, it was claimed, lay in "Functional"
principles that would speed and improve communication. Driven
by an overriding concern with typographic efficiency, Herbert
Bayer, also at the Bauhaus, proposed the abolition of upper-case
letterforms, claiming that they were phonetically redundant.
Photo-montage and experimental photography would offer a new
and inherently photographic way of seeing. The first generation of
magazines exploring modernist principles were often published by
the designers themselves. By the late 1920s they were shaping the
pages of popular titles, like the German magazine *Die Neue Linie.*

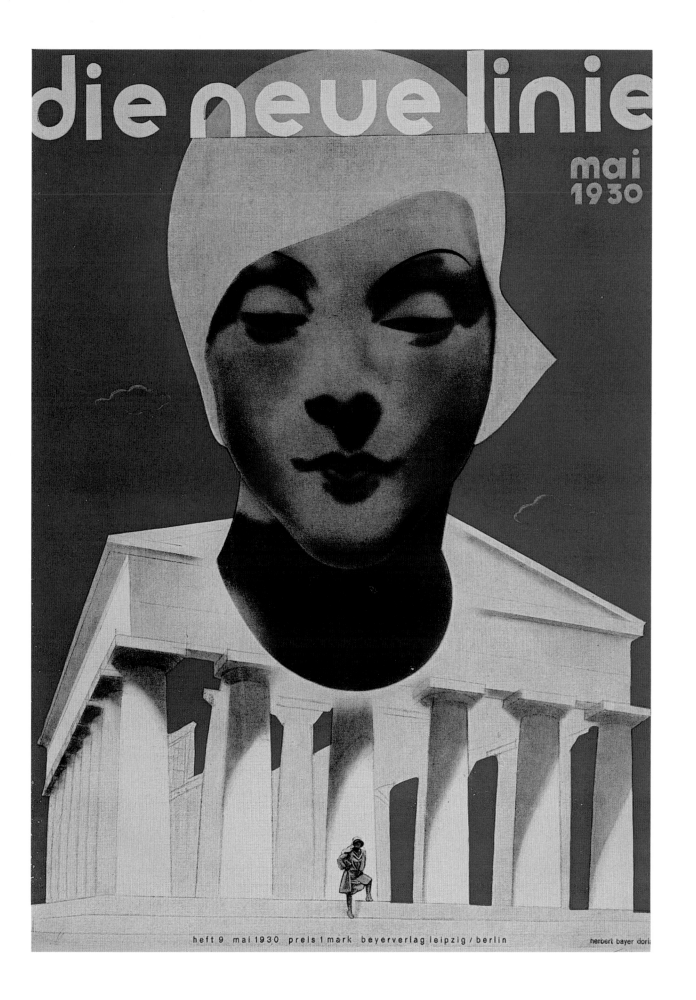

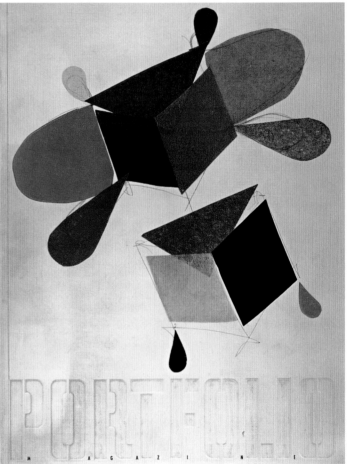

1953 *Left:* The cover of the Spring issue of *Gentry* by W Lully under the art direction of William C Segal adopts the découpage technique developed by French painter Henri Matisse. Cutting and composing coloured paper in expressive shapes, Segal conjured up a picture of affluent leisure.

MODERNISM IN POST-WAR AMERICA

Avant-garde innovations in art in the first half of the 20th century were given a new lease of life in America after the Second World War. A new wave of gifted art directors – some native and others who had left crisis-torn Europe during the 1930s – employed elements of the abstract language and compositional principles of modern art in a remarkable group of magazines of the 1940s and 1950s (see also the sections on American *Vogue* and *Harper's Bazaar*). Driven by a strong commitment to the elevating power of culture, designers and publishers such as William C Segal of *Gentry*, a short-lived men's magazine, had high aspirations for their titles. Segal's magazine, which covered subjects as diverse as modern art, menswear, and philosophy, was to have a "civilizing influence" on middle-brow America. Fleur Cowles, art director of *Flair* magazine, claimed that the first issue of *Flair* was "proof that a magazine need no longer be stolidly frozen to the familiar format". She assured the reader that they could expect "the most delicious of all rewards – a sense of surprise". Although by no means anti-commercial, these titles eschewed the often sentimental imagery that dominated much American magazine publishing at that time.

1950 *Above: Portfolio,* a short-lived magazine art directed by Alexey Brodovitch, has a legendary status today. This embossed metal cover is illustrated by a design for a kite by American architect Charles Eames.

1950 *Right:* The image of a wing on the cover of the February issue of *Flair,* art directed by Fleur Cowles, is embossed, and its shadow die-cut, revealing a trace of a drawing on the page underneath.

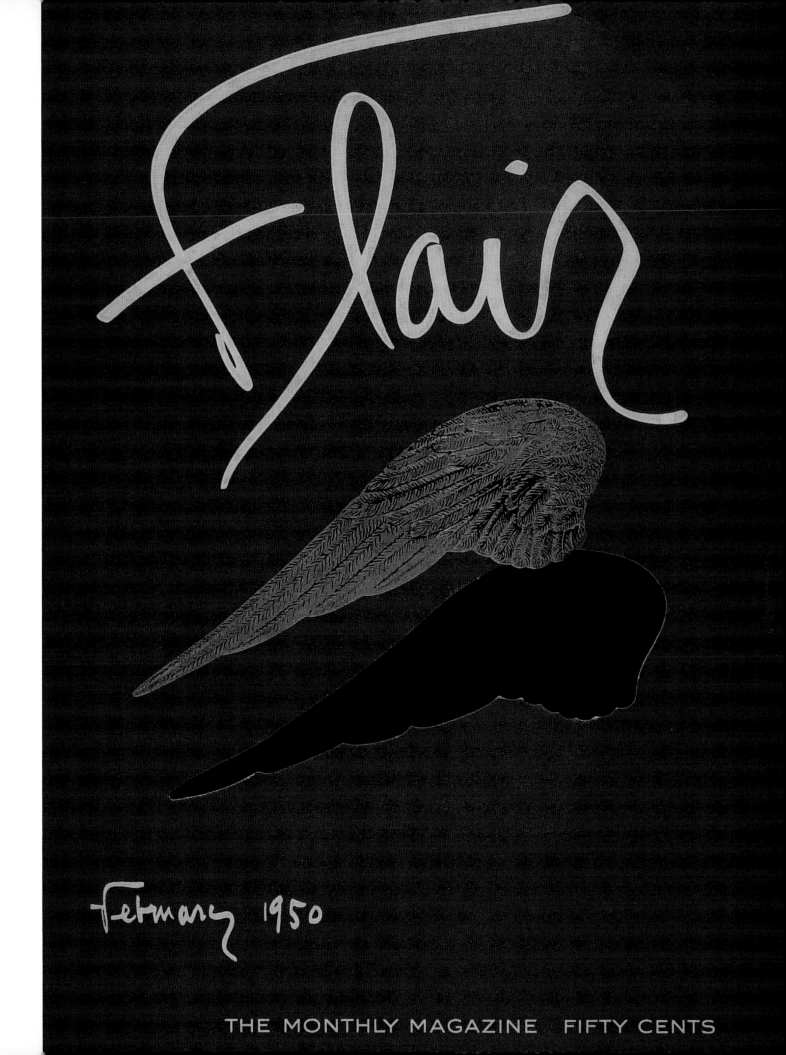

Flair

February 1950

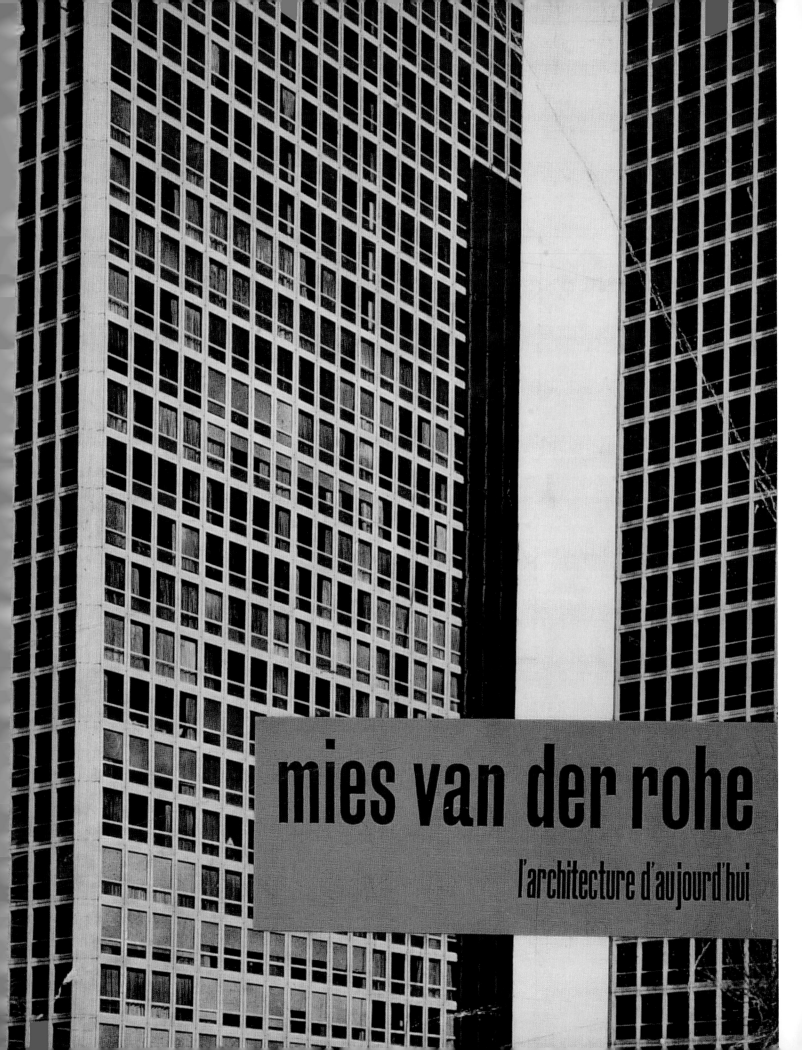

mies van der rohe

l'architecture d'aujourd'hui

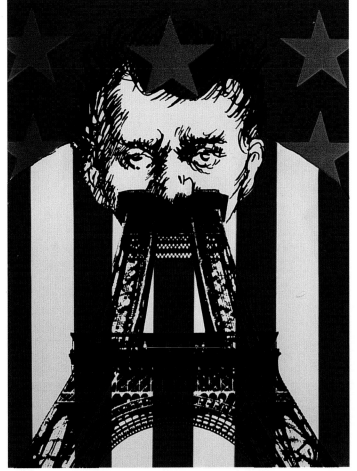

1968 *Opposite:* Cieslewicz's design for the fourth issue of *Opus* reflected the desire of many European intellectuals during the Cold War to forge a culture that was neither a servant of capitalism nor an apologist for Soviet socialism.

1967 *Left:* Cieslewicz's design combined the "Star-Spangled Banner" with a symbol of modern France, the Eiffel Tower, to introduce the theme of "American art in France". The drawing is by Roland Topor.

1967 *Below:* This issue of *Opus* surveyed the work of French director and film writer Jean-Luc Godard. Captioned "The Truth Eye" Cieslewicz's design included a lenticular disc over Godard's glasses that appears to spin as the viewer moves, a subtle comment on the subjective "truth" of perception.

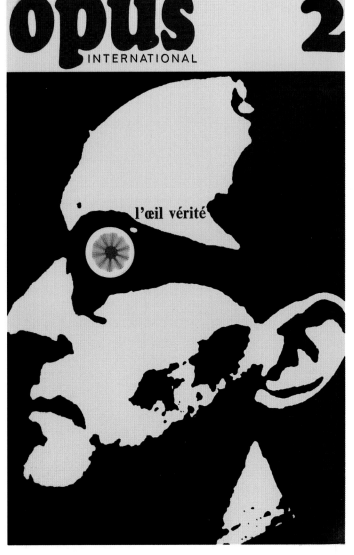

l'œil vérité

OPUS INTERNATIONAL WAS FIRST PUBLISHED BY GEORGES FALL IN PARIS AT THE END OF THE 1960S, A PERIOD OF GREAT CULTURAL AND POLITICAL TURMOIL. In May 1968, students and intellectuals took to the streets of Paris to protest about the consumerism of French society and the conservative social vision represented by De Gaulle's government. These protests represented a long-established view that the kind of modern societies that had taken shape in Western Europe after the Second World War had trained people to be passive and uncritical subjects. Although not explicitly political, *Opus* was infected with this viewpoint. Its writers protested against the "Alice in Wonderland" world of advertising or the moral vacuum at the heart of politics. Roman Cieslewicz's covers offered a commentary on European culture in an age of turmoil. A Pole who left Warsaw in the early 1960s (see pages 54-55), Cieslewicz had forged a successful career designing *Elle*. Free from the constraints of commercial publishing, *Opus* offered a cover space where he could pass comment on the world. Lacing the dead-pan style and commercial imagery favoured by Pop Art with a vein of irony, he reflected a desire, shared by many of his contemporaries, to escape the pull of commerce.

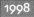 **1998** *Below:* Tim Young's cool and elegant cover design for the major American graphic design magazine, *Print*, emphasizes the abstract geometry of the pixel behind all digital imaging techniques.

2002 *Opposite:* British magazine *Eye* designed by Nick Bell reproduces an image of the Queen from *The Daily Telegraph*. On first impression the coloured discs appear to suggest the pixels of a computer screen. Their variable size creates a powerfully impressionistic effect.

2003 *Right:* For an issue featuring an article on the overflowing archive of British designer Peter Saville, *Creative Review*'s art director Nathan Gale reproduced a detail of original marked-up artwork for a New Order record cover.

2001 *Below:* This issue of *Emigré* – an American magazine with cult appeal among graphic designers throughout the world – was given over to Mieke Gerritzen, a designer from the Netherlands. A kind of manifesto advocating the democratization of design, Gerritzen argued that everyone has the capacity to be the "designer of their own digital domain".

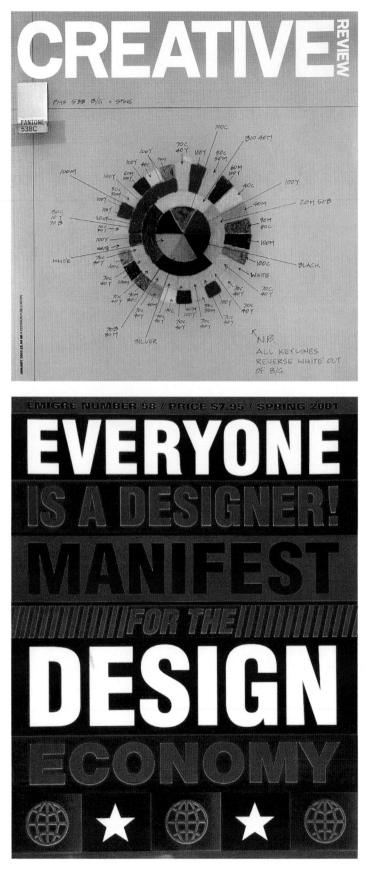

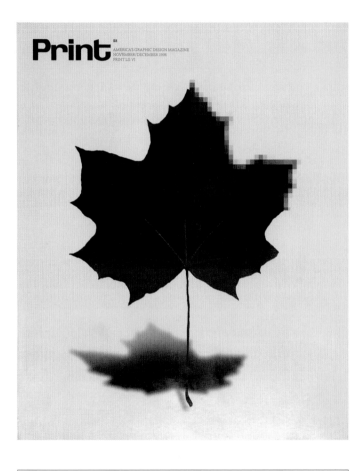

THE GRAPHICS PRESS TODAY

In the last fifteen years the practice of design has been transformed by digital technology. Traditional layout and typesetting skills have been superseded and the long-established status of the photograph as document has been undermined. Some have lamented these changes while others have welcomed digital culture as a brave new world. Naturally, the graphic press has been at the forefront of reporting this revolution. For illustrators and designers, the challenge has been to find ways of portraying abstract themes like the pulse of digital information down an ISDN cable or the social effects of living in a digital age.

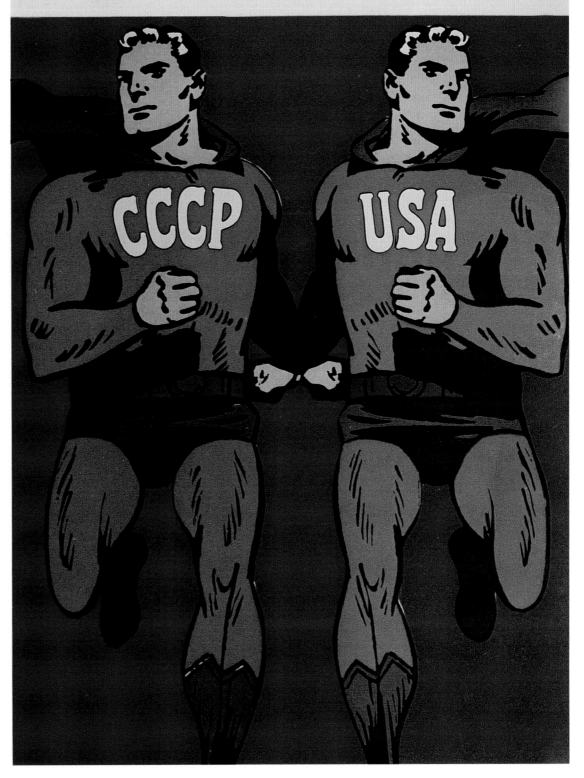

THE ART OF ART AND DESIGN MAGAZINES

Journal of the Royal College of Art price 2s 6d or 50 cents

ark 22

1952 *Right:* Illustrator David Gentleman's cover of *Ark 4* typifies what was known as "Festival Style", so called after the Festival of Britain in 1951. Drawing upon eclectic imagery and ornate Victorian display typefaces, the cover reflects the old-fashioned tone of much graphic design in the immediate post-war period.

1965 *Below:* A woman's torso with the title of the magazine projected on it featured on the cover of *Ark 38*. The artists responsible for this image, Robert Hyde and Peter Jones, projected images onto figures and spaces to produce what they called "environmental paintings".

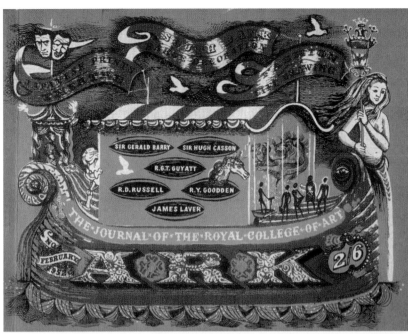

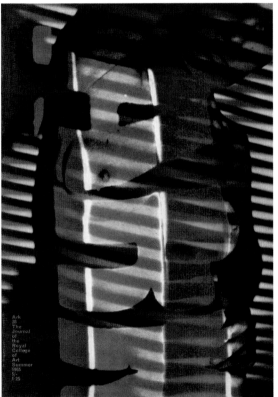

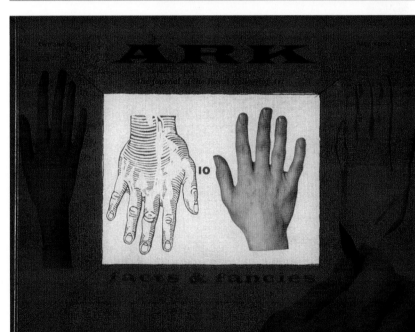

F EW COLLEGE MAGAZINES CAN CLAIM TO HAVE HAD THE INFLUENCE OR THE ACCLAIM ENJOYED BY *ARK,* PRODUCED AT LONDON'S ROYAL COLLEGE OF ART BETWEEN 1950 AND 1976. Although launched as a student magazine by Jack Stafford, it was never a typical student product. Not only was *Ark* expensive, it frequently featured the work of prominent artists and critics outside the college. Early issues were often earnest and literary, reflecting the tone of British cultural life in the austere years after the war. *Ark's* heyday was to come a few years later and was connected to the rise of Pop artists like Richard Hamilton (a tutor at the college) and writers like Reyner Banham who challenged the hierarchical divisions of culture that separated "high" from "low", "good" from "bad" taste, and art from design. Reviewing *Ark* in the *Sunday Times* in 1963, Mark Boxer wrote: "Often wilful, sometimes seriously naïve, occasionally ridiculous, it is at its best one of the most hopeful performances on the English visual scene".

1954 *Above:* Novelist Len Deighton trained as an illustrator at the Royal College of Art in the early 1950s. He used the cover of *Ark 10* to press the point that photography was as creative a medium as illustration.

1958 *Opposite:* Under the art direction of David Varley, *Ark 22* took a strong interest in abstract painting as this hard-edged design suggests.

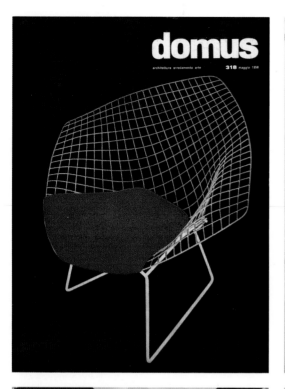

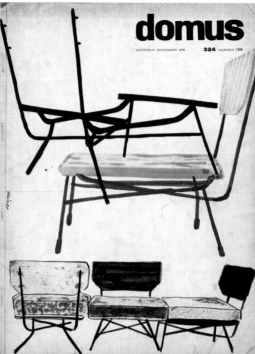

1958 *Opposite:* Hedrich Blessing's photograph of the Commonwealth Promenade buildings in Chicago, designed by Mies van der Rohe in 1957, was reproduced as a tightly cropped detail on the cover of *L'Architecture d'Aujourd'hui*. Like an illustration of Mies's favourite dictum "Less is More", these architectural structures are reduced to their elements – a geometric skin composed of window mullions and panels.

1956 *Far left:* The Bertoia chair (made by Knoll) became one of the icons of post-war modern design. On the cover of architect Giò Ponti's *Domus*, its simple form was distilled into three elements.

1956 *Left:* Albe Steiner's montage for the cover of *Domus* transformed the structure of a Polotrona chair into an abstract composition.

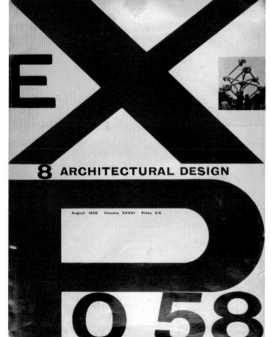

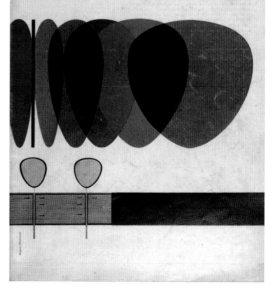

1958 *Far left:* This cover of *Architectural Design*, a London-based magazine, was designed by Theo Crosby, one of the founders of the Pentagram design group. This exercise in what the editors called "Experimental Typography" abbreviated the theme of the issue, the Brussels Universal Exhibition, to a series of expanded letters.

1960 *Left:* Under the art direction of Ken Garland, *Design*, a serious-minded British journal investigating "good design" achieved a balance of clarity with spirit. The coloured shapes on this cover represent the changing profile of the mirror as it turns on the dressing table below.

MODERNISM AND THE POST-WAR DESIGN PRESS

In the 1950s the architectural and design press had both an editorship and a readership with a strong commitment to the visual and intellectual force of modern design. Committed to creative freedom and relishing its "mission" to improve the world, modernism – in architecture and design – claimed experimentation as its raison d'être. Sentiment and nostalgia had no place in its brave new world. Yet despite their avowal of modernity and creativity, the style of the post-war design press was, in many ways, a vindication of older design thinking. On the Continent, the bold graphic confidence of these covers revived a tradition of modernism interrupted by the war (though they were a dramatic innovation in conservative Britain). Sans-serif typefaces and lower-case letters – once promoted as the embodiment of efficiency and rationality – became de rigueur. Although these "principles" of design did not inhibit creativity, by the mid-1960s they had fossilized into conventions.

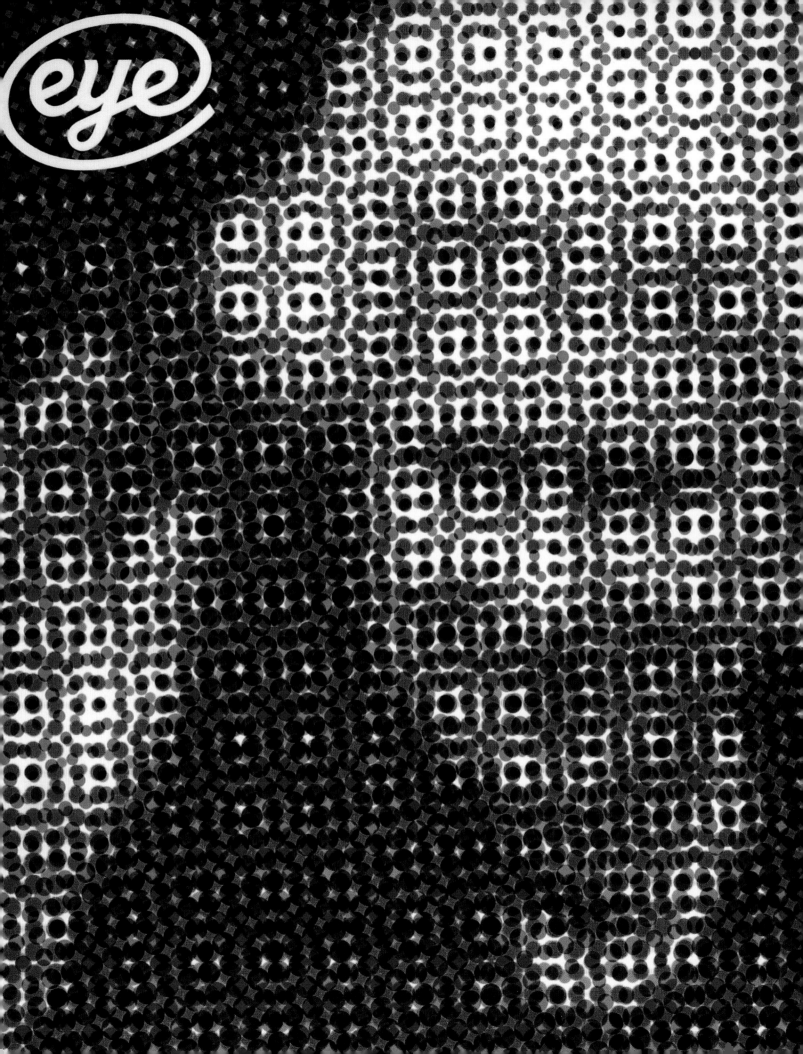

2000 *Below:* The self-consciously incongruous cover of the Czech magazine *Blok* represents the theme of communication through a generic portrait of an anime character.

2003 *Left:* This issue of American architecture and design title *Metropolis* tempts purchasers to flick through the magazine by a cover headshot and an enigmatic caption.

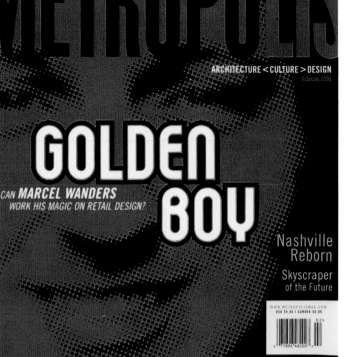

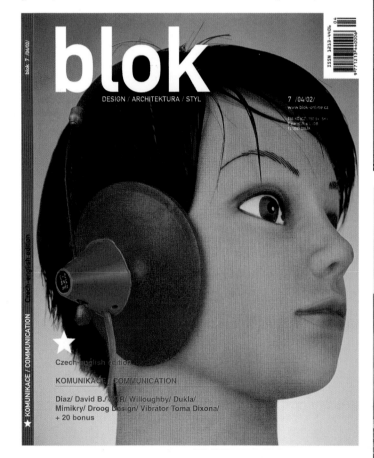

2002 *Opposite:* Using baroque decorative devices and 19th-century display faces, American "shelter" magazine *Nest* is placed in opposition to the slick late modernism of *Wallpaper*. The dizzying search for the unconventional led founding editor and art director Joseph Holtzman to cover Buckingham Palace as royal kitsch.

2002 *Right:* For a magazine that takes the consumption of modern design seriously, Jörg Koopman's beautiful monochrome image of an ancient Kouros from classical Greece might seem a wilfully obscure image for the cover of *Wallpaper*. It forms an introduction to a city guide to the shops, bars and hotels of Athens.

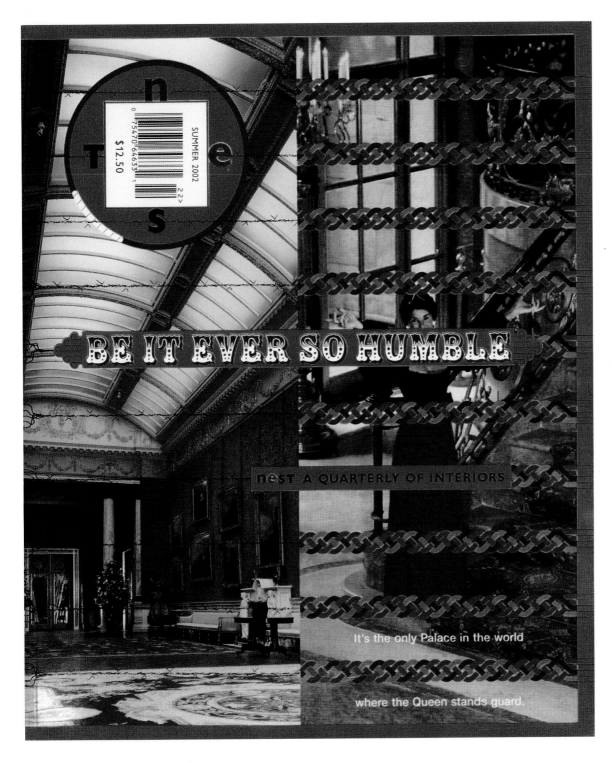

It's the only Palace in the world

where the Queen stands guard.

HIGH DESIGN ON THE HIGH STREET

Architecture and design for much of the 20th century were largely of interest to professionals and aficionados. In recent years, however, they have become standard fare in mainstream magazine publishing. Readers have become experts in the history of Modern Movement architecture or studio glass of the 1950s, as well as keen observers of the contemporary design world. What once seemed a clear and distant relationship between confident arbiters of good design and popular taste has become blurred. Fashionable designers borrow from the world of kitsch, while austere aesthetics like minimalism now have wide appeal. It is no longer possible to talk about avant-garde design, such is the warm embrace that the design media extend to new and perplexing design ideas. Magazines such as *Wallpaper* and *Metropolis* played an important role in the reinvigoration of design in the 1990s. In the world of the glossy design magazine, style – whether ascetic or baroque – is king.

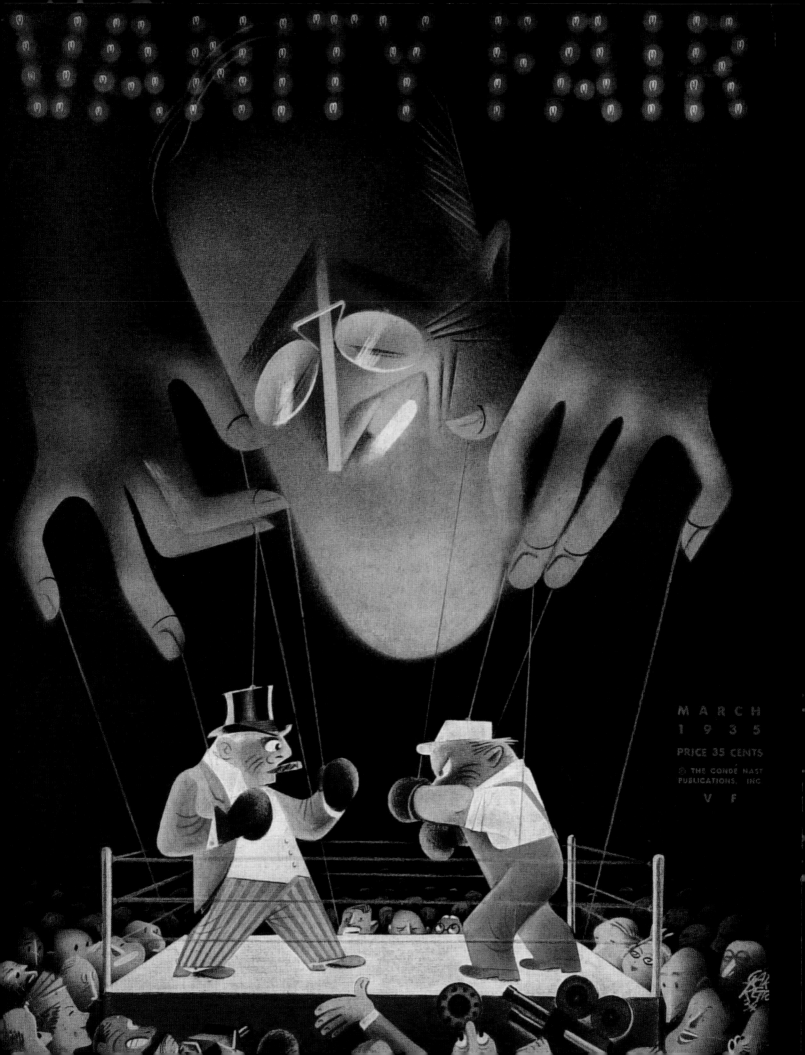

MARCH
1935

PRICE 35 CENTS

© THE CONDÉ NAST
PUBLICATIONS, INC.

V F

THE ILLUSTRATED COVER

...there are, all over the world, a great many modern magazines which use modern make-up (you may call it modernistic). But there are only a very few which use modern material. And you must get modern material first if you intend to publish a really modern magazine ...

Mehemed Fehmy Agha "What makes a magazine modern?" *Advertising Arts*, October 1930.

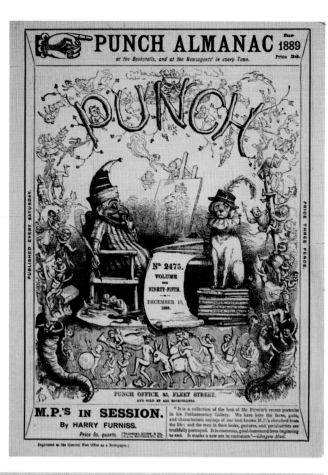

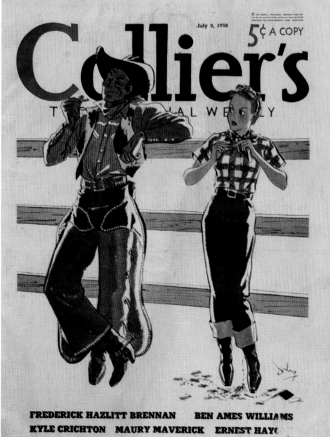

THE ILLUSTRATED COVER

It is hard to imagine the profession of the illustrator without the magazine. Whilst some artists have made their living illustrating novels – not least in the mid-19th century when novels such as *Pickwick Papers* by Charles Dickens first appeared in popular illustrated serial editions – magazines have demanded much more from their illustrators than mere vignettes. In some, the picture has even led the way. It was not unusual for the editors of science-fiction pulps in the 1930s to present a vivid image already destined for the cover to the writer and demand a story to suit. Other magazines like *The New Yorker* detached the cover illustration from the responsibility of capturing content, regarding the space as something akin to a weekly gallery.

The history of the illustrated cover intersects with the history of caricature and cartooning. The ease with which the pen or the brush can exaggerate people and situations has been the basis of a remarkable seam of social and political commentary that can be traced back to *Le Charivari,* founded in France in 1832 and *Punch* in England, first published in 1841.

1889 *Above left:* Although *Punch* led the field in illustrated satirical magazines in Britain, the opportunity to use the cover to sell the magazine and promote its contents was not seized in the 19th century. Each issue featured this elaborate drawing of the magazine's emblem, Mr Punch.

1938 *Bottom left:* The cover of this issue of *Collier's*, a popular American weekly, was illustrated with Gilbert Darling's bright and freely drawn watercolour commenting on women smokers, a theme that engrossed *Puck* during the struggles for women's suffrage (see page 38).

Illustrators – working with sympathetic editors – are only fettered by the limits of their technique. A fantasy world of space-travel and alien-encounters – unrestrained before the relatively mundane achievements of the space race – could be conjured on the covers of *Astounding Science* and *Science Fiction Quarterly*.

Far more serious-minded titles like *New Scientist* turned to the illustrator to symbolize abstract research or map ethical contours that the non-professional reader might find hard to follow.

This chapter also contains photographic illustrations alongside hand-drawn and painted imagery. While many photographers are drawn to their medium because of its apparent realism and capacity to capture what Cartier-Bresson called the "decisive moment", others have been more interested in its capacity to combine realism and illusion. The practice of photo-montage – the combination of two or more photographic images – both eschews and exploits the photograph's naturalism. To see someone familiar placed in an implausible setting can have great caricatural effect. But, as the work of John Heartfield, the anti-Nazi photo-montage artist of the inter-war years, testifies, it can also produce powerful "truths" denied to the straight photograph.

1992 *Top right:* During the 1990s *New Scientist* under the art direction of Deborah George regularly featured illustrations on its cover. Peter Maynard's collage employs the historic imagery of the 16th century herbal to introduce an article on the flowering of plants.

1992 *Bottom right: Spy*, a leading satirical magazine in the United States since 1986 (check), regularly use montaged images on its covers with great satirical effect. Produced on screen, this image by John Millio of President Clinton combined stock and press photographs with a staged shot of a costume specially commissioned for the cover.

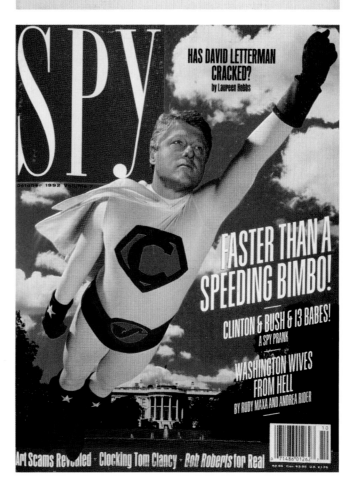

1910 *Below: Puck,* an American title modelled on *Punch* in Britain, took an agnostic stance on the question of women's suffrage. Issued ten years before women achieved the vote in America, this cover passes comment on the pressing social question of the right of a woman to smoke in public.

1907 *Right:* The brutal reign of Tsar Nicolas II triggered protest in Russia at the beginning of the 20th century. In 1905 the authorities put down peaceful protests in St Petersburg with great brutality. The response was a flood of radical, satirical journals, mostly produced in Moscow and St Petersburg. The cover of *Voron* (Raven) depicts a raven feeding an insect to her chicks, symbolizing greed and cruel power.

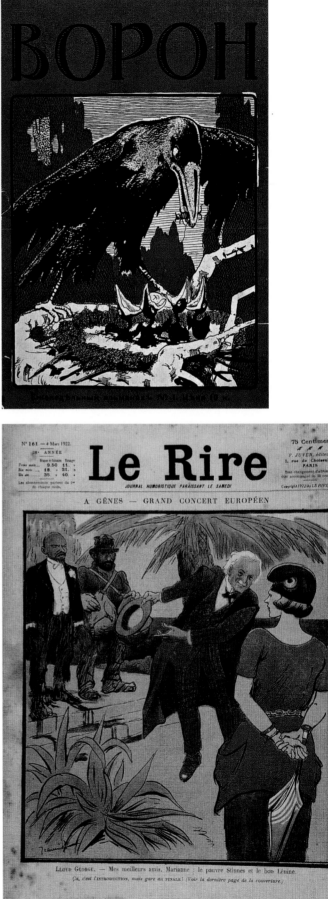

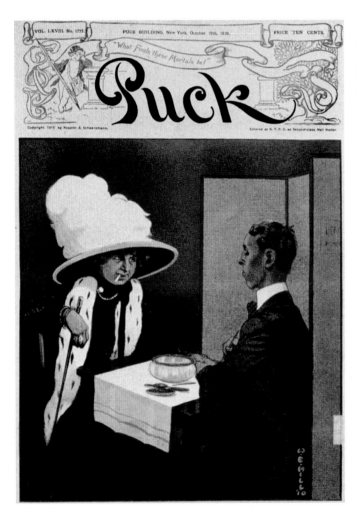

SATIRE: LATE 19TH TO EARLY 20TH CENTURY

Satire often flourishes in periods of conservatism. While narrow social conventions and pompous rulers have attracted the wrath of hot-headed demonstrators, satire – with its cooler strategies of exaggeration and Aesopian symbolism – is often able to capture injustice with greater effect. Satirical magazines boomed before the First World War with writers and artists using their skills to challenge authority's refusal to engage social and political change.

München, 2. Januar 1911

15. Jahrgang Nr. 40

SIMPLICISSIMUS

Abonnement vierteljährlich 3 Mt. 60 Pfg.

Alle Rechte vorbehalten.

Begründet von Albert Langen und Th.Th. Heine

In Oesterreich-Ungarn vierteljährlich K 4.40

Copyright 1911 by Simplicissimus-Verlag G. m. b. H., München

Prosit Neujahr!

(Zeichnung von E. Thöny)

1911

1911 *Right: Simplicissimus* was one of the most beautiful satirical journals of the period, largely because its publisher, Albert Langen, drew upon the talents of the large numbers of Jugendstil artists based in Munich. The cover of this New Year issue illustrated by Eduard Thöny reflected on class interests. Thöny was the magazine's most prominent illustrator, renowned for his character portraits and study of body language.

1922 *Opposite below: Le Rire,* a leading French satirical magazine, was published for almost fifty years. Jeannoit's cover depicts British Prime Minister Lloyd George introducing Marianne, the symbol of France, to a blood-stained Lenin, leader of Soviet Russia.

The Listener. October 6, 1955. Vol. LIV. No. 1388.

PRICE FOURPENCE

The Listener

Published every Thursday by the British Broadcasting Corporation

Wood-engraving by Derrick Harris

Autumn Book Number

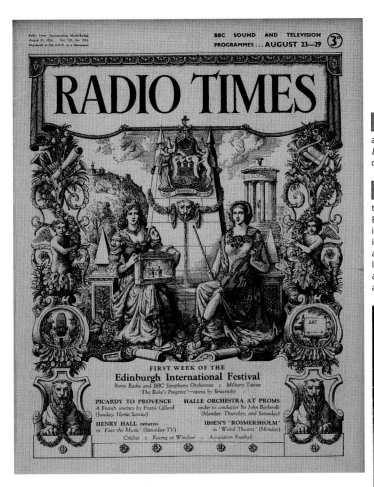

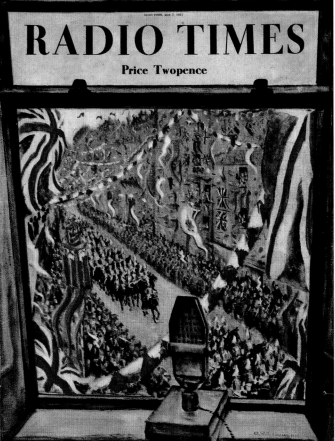

1955 *Opposite:* Derek Harris's charming wood engraving appeared on the cover of *The Listener*, the reading classes' journal of choice.

1953 *Left:* W McLaren's design for an issue of the *Radio Times* promoting the Edinburgh Festival gave the impression of an engraving. With its combination of classical devices and state-of-the-art technology like the camera, it presented a jarring combination of tradition and modernity.

1937 *Above:* Selling more than 3.5 million copies, the special issue of the *Radio Times* published for George VI's coronation was the most successful ever. It features a painted coronation scene painted by CWR Nevinson, from the privileged vantage-point of the radio commentator.

ILLUSTRATED GOOD TASTE

The Listener, established in 1931, and the *Radio Times*, first produced in 1923, provided the public with information about programmes broadcast by the British Broadcasting Corporation. Like the BBC itself, the *Radio Times* was (at least until the 1990s) not a wholly commercial venture, but a cultural one that sought to balance "highbrow" values with "downmarket" appeal. It is not surprising that the design of the magazines' covers sought to achieve this balance too. In a self-conscious contrast to the sentimental and colourful pictorial images used by popular women's magazines, the *Radio Times* and *The Listener* often employed wood engravings, a traditional and self-consciously English image-making technique. While monochrome, linear images were well suited to the needs of these inexpensive weeklies, their regular appearance in mass readership magazines like the *Radio Times* was also a triumph for the woodcut revival of the 1920s. Artists such as Eric Gill had argued that wood engravings could "illustrate, clarify and illuminate" the books in which they appeared. The tradition of wood engraving and the culture of good taste that it represented lasted well into the post-war period, not least because of the impecunious state of the British economy. Colour did not return to the cover of the *Radio Times* until 1964.

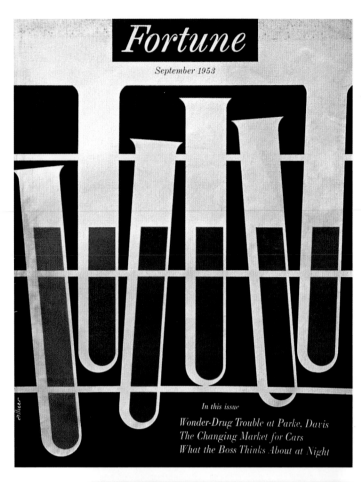

Fortune
September 1953

In this issue
Wonder-Drug Trouble at Parke, Davis
The Changing Market for Cars
What the Boss Thinks About at Night

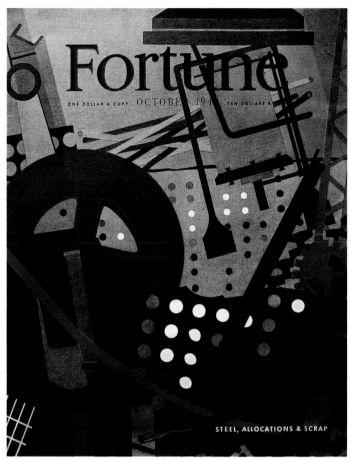

STEEL, ALLOCATIONS & SCRAP

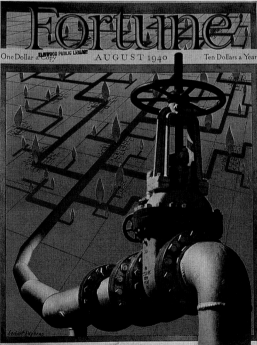

1936–1953 *Above:, top left and right: Fortune's cover artists produced powerful graphic images and abstract designs to represent heavy industries and complex technologies.*

Opposite: Published to coincide with the primaries for the 1936 elections, this cover was illustrated by Antonio Petruccelli, a regular cover-artist during the first phase of Fortune's life.

A LARGE, PERFECT-BOUND, WELL-ILLUSTRATED AND EXPENSIVE MAGAZINE, *FORTUNE* FIRST APPEARED ONLY A FEW MONTHS AFTER THE WALL STREET CRASH.

Yet it proved to be both a commercial and a design success. Publisher Henry Luce promised his readers expert analysis of the world of business, science, and manufacturing, as well as "the most beautiful magazine" in America. By the appointment of visionary art directors who, in turn, employed many innovative artists and designers, Luce achieved his aim. For the first decade, *Fortune's* cover illustrations were framed by the trompe l'oeil effect of window that suited the "monumental" illustrations commissioned by the magazine's first art director, Eleanor Tracey. Many of this generation of *Fortune* cover designers were prominent European artists who had fled the war. After 1945, as William Owen has argued, the centre of the American economy shifted away from heavy industry to marketing and corporatism. The magazine's design changed too. In 1949 Leo Lionni, a designer who had been close to the Futurists in his native Italy before the war, took over as art director. Working closely with Walter Allner, a former Bauhaus student, he brought a clinical and restrained approach, suited to the world of management consultants and marketing departments.

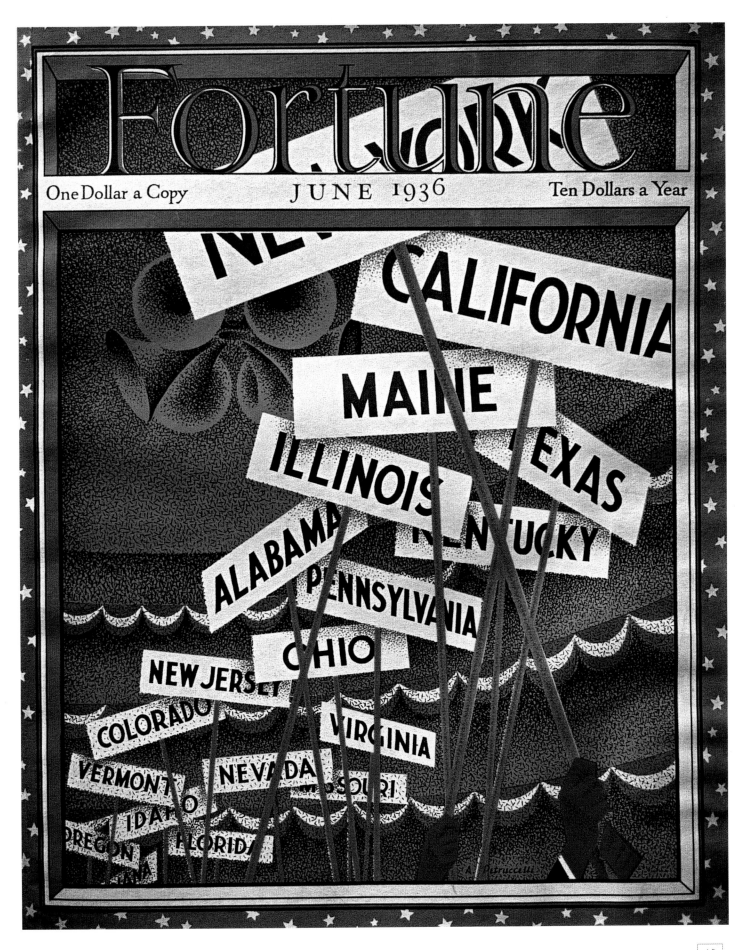

THE ILLUSTRATED COVER

1940 *Left:* John Newton Howitt's painted cover image symbolizing jealousy is a vivid character study.

1952 *Above:* This cover by illustrator Coby Whitmore featured what became one of the most controversial symbols of American affluence in the 1950s, the car. Like the glamorous woman at the centre of the image, Detroit's automobiles were increasingly styled according to the dictates of fashion.

I T'S A REMARKABLE FACT THAT *THE SATURDAY EVENING POST* COULD ENJOY ALMOST 150 YEARS OF CONTINUOUS PUBLICATION INCLUDING TIMES OF WAR AND DEPRESSION, AND YET IT FOLDED IN 1969 AT THE HEIGHT OF AMERICAN PROSPERITY. A family title which was read by the white middle classes, its conservative view of life could not survive the cultural ferment of the late 1960s, nor the appearance of other magazines more closely targeted to specific markets. *The Saturday Evening Post*'s America was a place where civil rights was hardly a matter of concern and women, despite their role in public life and the workforce, were usually in their "natural" habitat, the kitchen. When it ceased publication, the magazine's appeal to sentiment appeared tired and trite. Today, however, *The Saturday Evening Post* is wrapped in nostalgia. Its cover illustrations – particularly by its best-known artist Norman Rockwell who was responsible for more than 300 of them – are often reproduced as they symbolize an era of lost innocence and affluence. As cultural historian Paul Grainge argues, nostalgia of this kind aestheticizes and commodifies the past. It is perhaps not surprising that *The Saturday Evening Post* continues to exist in the form of images on tea-towels, postcards, and posters.

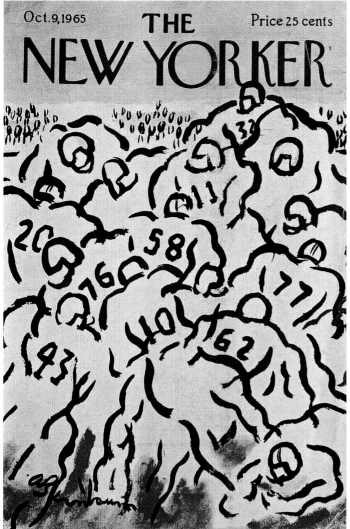

Oct. 9, 1965 · THE NEW YORKER · Price 25 cents

1965 *Left*: This powerfully simple cover depicts the tumult of an American football match in a series of economical brushstrokes.

1939 Opposite: Constantin Alajálov was one of the most prolific illustrators of mid-century America. His work appeared on the covers of *The New Yorker*, *Fortune* and *Saturday Evening Post*. This cover gently satirizes the high-life and cultural pretensions of America's elites.

1958 Below: In a remarkable and long career, Arthur Getz's art first appeared on the cover of *The New Yorker* in 1938 and his last appeared in 1988. Like many of his best images, this cover captures a key element in the city's mythology: jazz. At the time that this cover was published, "cool" West Coast jazz was at the height of its appeal.

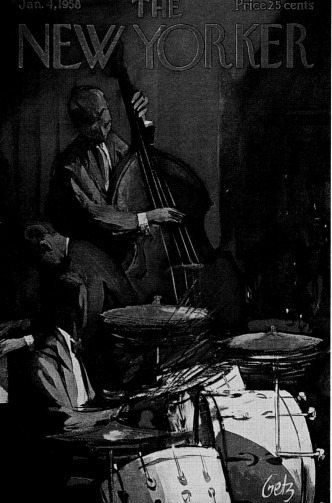

Jan. 4, 1958 · THE NEW YORKER · Price 25 cents

*T*HE NEW YORKER MAGAZINE, FOUNDED IN 1925 BY HAROLD ROSS, HAS BEEN A REMARKABLY CONSISTENT PRODUCT IN THE FASHION-CONSCIOUS WORLD OF MAGAZINES. The magazine's mission to deliver the best writing – short stories, power-dry satires, or lengthy commentaries on culture – has never wavered. This policy is also reflected in its attitude to design, eschewing the photographic image throughout its existence. The painted and hand-drawn images that feature on its covers, often based on impressionistic or gently humorous views of city life, emphasizes the magazine's interest in craftsmanship and skill. Craft cannot always be hurried, even on a weekly magazine. Arthur Getz – one of the magazines most prolific cover artists – had, for instance, to wait almost two years before the first cover artwork that he delivered in 1936 appeared in print. The accolade "timeless" is often glibly awarded, but in the case of *The New Yorker*, the fact that many of its covers could have been published at any time in the post-war period is testimony to the magazine's consistency and staying-power.

SCI-FI PULPS

The genre of the science fiction pulp was initiated by Hugo Gernsback's *Amazing Stories* magazine in 1926, which promised its readers insight into the future applications of science. However, the genre's interest in what Gernsback called "scientification" was soon overshadowed by its readers enthusiasm for fantasy, as BEMs (Bug Eyed Monsters) and scantily-clad maidens from the future became central characters. Ephemeral and cheap products,

sci-fi pulps were held in low regard by cultural commentators during their heyday. Now, these magazines are highly collectable, not least because of the vivid and visionary artwork that graced their covers. While the genre introduced the writing of excellent writers like Robert Heinlein and Raymond Bradbury, it was the artwork that shaped the issue. Writers were often asked to "illustrate" artwork with a story. As Heinlein himself once lamented of the publishers of the titles in which his writing appeared: "They didn't want it good, they wanted it Wednesday".

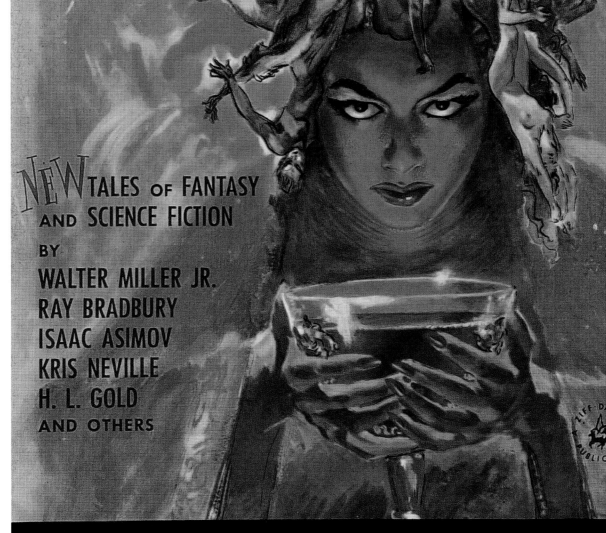

fantastic

ANC

35¢

NEW TALES OF FANTASY
AND SCIENCE FICTION
BY
WALTER MILLER JR.
RAY BRADBURY
ISAAC ASIMOV
KRIS NEVILLE
H. L. GOLD
AND OTHERS

ZIFF-DAVIS PUBLICATION

Plus A CLASSIC NOVEL BY **RAYMOND CHANDLER**

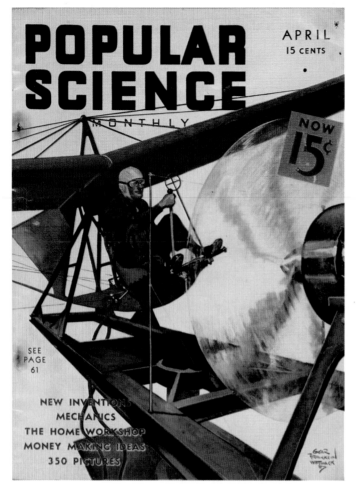

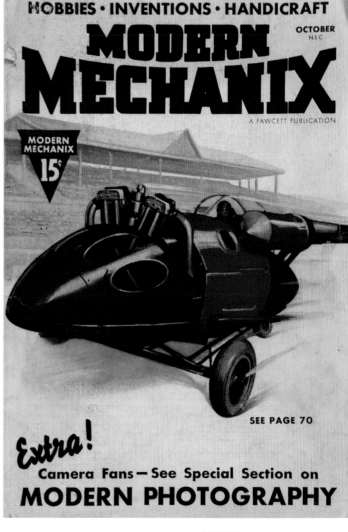

1937 *Left: Popular Science,* launched in 1872, was one of the earliest technical magazines. This issue features Edgar Franklin Wittmack's impression of a training glider.

1937 *Below:* Although the rocket-powered car that featured on the cover of this issue of *Modern Mechanix* was a real invention and had been tested in France, the dingy and static photograph inside could not compete with the dramatic illustration that was used on the cover.

1954 *Opposite: Newnes Practical Mechanics* was the leading hobby title in post-war Britain. In its search to emphasize novelty during a period known for its austerity, its editor sometimes featured bizarre objects like this "electric guitarette".

EVERYDAY EXPERTS

Practically minded magazines like *Popular Science* and *Modern Mechanix* reflected the increased leisure time and growing affluence of ordinary people in the 20th century. A new wave of increasingly complex mechanical objects – including cars, radios and cameras – entered into people's lives. These magazines set out to explain how they worked and to whet the appetites of consumers for new gadgets and gizmos. Like many science-fiction titles of their day, they offered vivid speculation on the future of technology. Most covers featured watercolour illustrations: the power of the imaginative artist was greater than the camera. In fact, many of the illustrations inside the magazine appear disappointing when compared to the exciting visions of speed and fantasy that graced their covers. These titles invariably feature men on their covers; the future was – it seems – to be man-made. Artist Edgar Franklin Wittmack's work also featured on the cover of *Saturday Evening Post* and *American Boy.* He specialized in square-jawed, broad-shouldered soldiers and adventurer-heroes. On his covers for *Popular Science,* the reader's DIY activities and hobbies were likened to the deeds of pioneers and inventors.

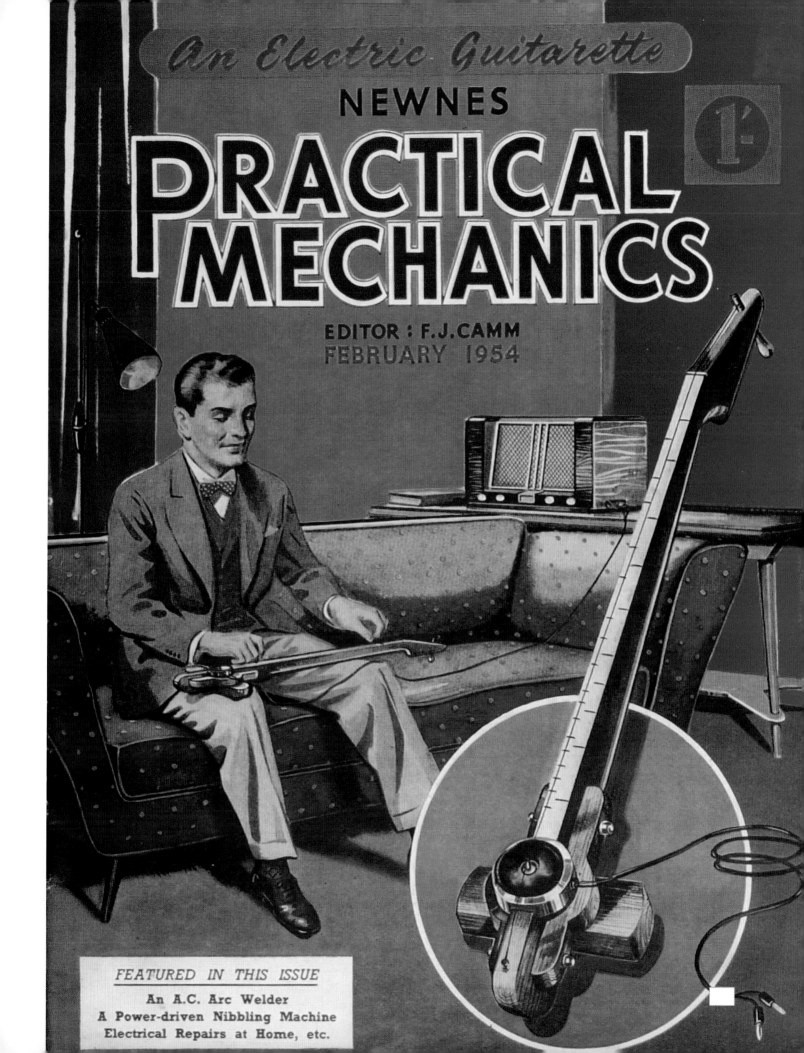

An Electric Guitarette

NEWNES
PRACTICAL MECHANICS

EDITOR : F.J.CAMM

FEBRUARY 1954

1/-

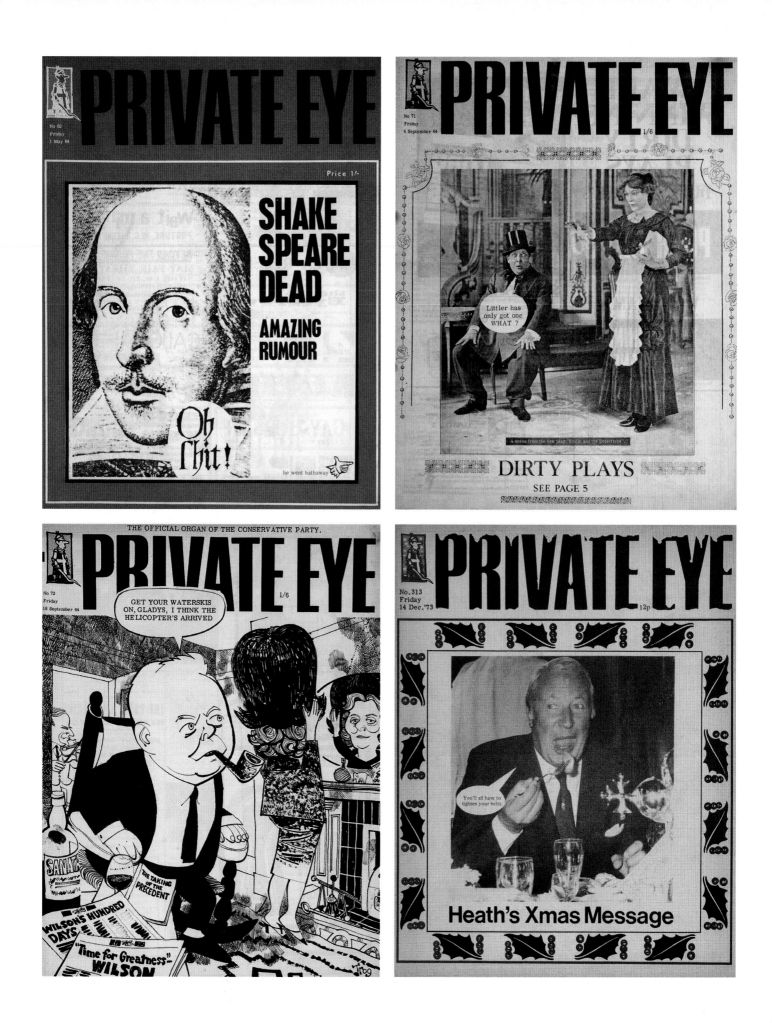

PRIVATE EYE WAS AN IMPORTANT PART OF THE SATIRE BOOM THAT RIDICULED CONSERVATIVE ATTITUDES IN BRITAIN IN THE EARLY 1960S.

The stifling and condescending views of the ruling classes – represented by the prosecution of Penguin books for publishing DH Lawrence's novel *Lady Chatterley's Lover* in 1960 and the requirement that all plays on the London stage be sanctioned by the Lord Chamberlain's Office – was challenged by a new wave of young satirists on the stage (*Beyond the Fringe*), on television (*That Was The Week That Was*), and on the pages of *Private Eye*.

Founded in 1961 by a group of Oxford University graduates including Richard Ingrams and Christopher Booker, *Private Eye* grew rapidly, becoming a difficult thorn in the side of the British establishment. With many of its battles over censorship and moral censure won, since the mid-1960s *Private Eye* has largely aimed its satirical arrows at politicians. Its cover – generally composed with "borrowed" press photos with sardonic captions and speech-bubbles attached – has been its principal weapon. In the last forty years, politicians, following the lead of skilled American media manipulators like John F Kennedy who perfected the art of the photo opportunity, have learned how to use the media to their benefit. With their dry captions, *Private Eye*'s covers reveal the artifice of a world where images are often more important than action.

1964–1973 *Opposite bottom left and right: Private Eye* occasionally featured the work of cartoonists on its covers. This image by Fleet Street satirist Trog comments on Prime Minister Harold Wilson's ego. The cover of 14th December 1973 issue of *Private Eye* featuring British Prime Minister Edward Heath appeared at a time of economic recession that led to the three-day working week in the months that followed.

1964 *Opposite top left and right:* Reflecting a desire to extend freedom of expression in Britain in the hidebound early 1960s, the cover of the 4th September 1964 issue satiries the moral outrage that accompanied a season of performances by the Royal Shakespeare Company in London.

1978–1982 *Above:* For a politician known for the strength of her convictions, Margaret Thatcher was also a shrewd media operator. Under the guidance of Gordon Reese, she was "repackaged" in the late 1970s to emphasize her ordinary appeal. This cover highlights her ruthless political ambition. *Above right:* Ronald Reagan's first career as an actor provided *Private Eye* with a rich supply of absurd images. This cover, using a still from *Bedtime for Bonzo* (1951), comments on American Secretary of State Alexander Haig's attempts to mediate between Britain and Argentina over the Falklands War.

T Y i J A

LISTOPAD 1966 ● MAGAZYN ILUSTROWANY ● NR 11 (79) ● CENA 12 ZŁ

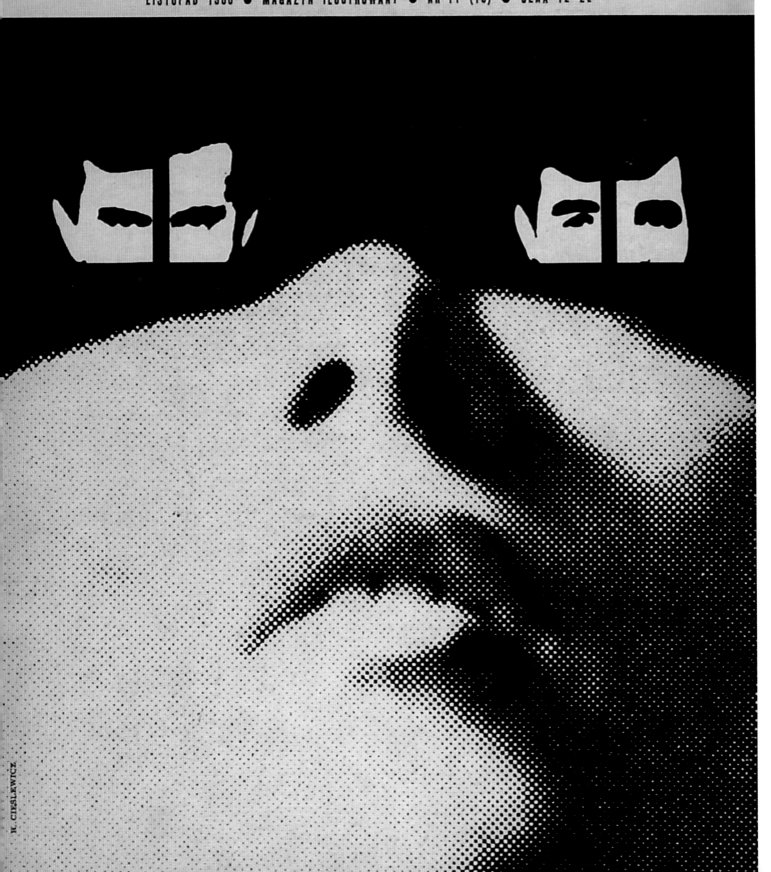

R. CIEŚLEWICZ

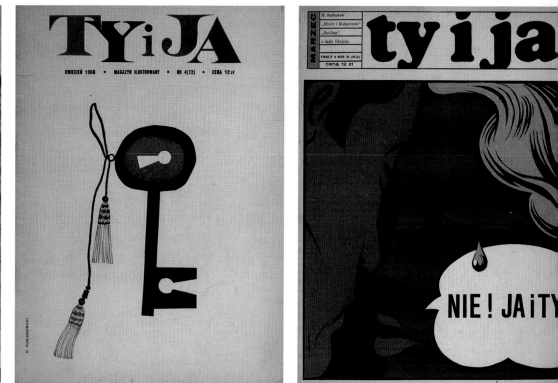

TY I JA (YOU AND I),
A MONTHLY PUBLISHED
IN POLAND FROM 1960,
DISPLAYED FEW OF THE
CHARACTERISTICS THAT
ONE MIGHT EXPECT OF
A MAGAZINE FROM THE
EASTERN BLOC.

The magazine took no interest in the activities of the grey Communist Party leadership or the achievements of the Soviet Union. When Soviet material did feature, it was the heroic, Constructivist avant-garde of the 1920s that was given attention (see page 60-61). Interested in searching out excitement and change, the drama of the 1917 revolution still had a romantic and visionary appeal to Ty I Ja's editors. Moreover, it served to emphasise the drab state of Eastern Bloc socialism. In fact, the magazine's focus on fashion, modern art and

interior design meant that its editors paid far more attention to Paris and New York than to Moscow. Highly metropolitan in its tastes, the magazine was produced by a group of artists and writers who disdained the manipulation of culture by the authorities. They included Roman Cieslewicz, who was the magazine's art director. After working on this Warsaw-based magazine, he had a successful career in Paris as art director of Elle. Always in short supply, this magazine was genuinely popular while its competitors, often dull and politically correct, were left unsold in the news kiosks. The magazine's editors were not under pressure to sell the title with seductive photographs or tantalizing captions on the cover. Cieslewicz and the prominent illustrators and

graphic designers who were commissioned to design the covers were able to exercise a great deal of artistic freedom. Their designs reveal a shared interest in collage and surrealism, practices that had developed in France and Germany in the 1920s and still sustained some of their subversive character in Eastern Europe in the 1960s.

Ty I Ja was closed down by the authorities in the early 1970s. The editors courted controversy by reporting social themes like free love. The new regime that took over in 1970 viewed the avant-gardism that this magazine represented as a threat to the sober, family values that it wanted to promote. Ty I Ja was eventually replaced with the Family Magazine, a far more conventional title filled with knitting patterns and recipes.

1965–67 *Opposite:* Roman Cieslewicz's montage on the cover of the November 1966 issue of *Ty I Ja* offers an allusive comment on sexual desire. *Above left:* Cieslewicz's December 1965 cover – with an enigmatic figure falling through the ranks of saccharine angels – reflects his surrealist sensibility. *Above middle:* Henryk Tomaszewski's charming illustration of a key features on the cover of the April 1966 issue. *Above right:* The March 1967 cover by Cieslewicz acknowledges the Pop Art aesthetic fashionable in North America and Western Europe.

LIFE

HIGHEST PHOTOS OF EARTH TAKEN BY MAN

85 miles up,
Astronaut Collins
photographs earth
as Gemini 10
approaches Agena 10
for docking

AUGUST 5 · 1966 · 35¢

COVERING THE WORLD

To see life; to see the world; to eyewitness great events; to see strange things ... to see man's work ... to see and take pleasure in seeing; to see and be amazed ... to be instructed. Thus to see, and be shown, is now the will and the expectancy of half of mankind.

Henry Luce, prospectus announcing the publication of *Life* magazine, 1936

1888 *Right*: 19th-century "penny dreadfuls" – cheap scandal sheets blending "violence, boisterousness, and cruelty" – reveal much about the appetite for news of affairs that conventional Victorian newspapers would not cover for fear of shocking their readers.

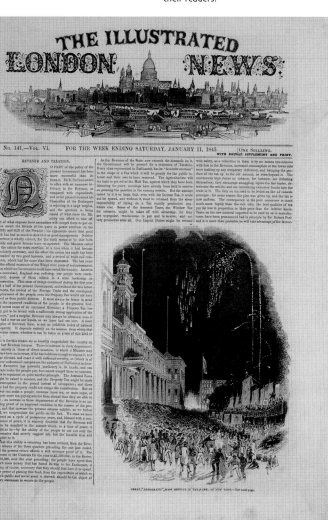

1966 *Previous page: Life*, the American photo-journal, offered its readers the chance to see the world from a new perspective in photographs taken by NASA astronaut, Mike Collins, on Gemini 10.

1845 *Above*: The engraving on the cover of *The Illustrated London News* is captioned "Great 'democratic' mass meeting at New York". The editors of the London magazine had to wait for the arrival of packet ships in Liverpool for news of events across the Atlantic.

1966 *Opposite:* Under Eberhard Wachsmuth's art direction, *Der Spiegel* featured some strikingly effective covers that summed up political and economic affairs with great economy. This 1966 cover reads "America's Invisible Power. The Actions of the US Secret Service, the CIA".

COVERING THE WORLD

Although magazines operate at a different tempo from the mainstream news press, they can offer seasoned reflection and commentary on affairs rather than report the drama of events as they unfold. They also illustrate the news – a function that was all the more important when papers were not illustrated. This has, however, rarely been a straightforward matter. The cover of the first issue of *The Illustrated London News* in 1842, for instance, depicted the city of Hamburg consumed with fire. The editors lacked an accurate image of the city, so they took an existing engraving and added flames. Even if the cover did not truly capture the tragedy in the city, the success of the magazine revealed the desire for illustrated news.

Magazines shape the way we view the world. After the Second World War, for instance, the allied forces occupying Germany conceived the idea of publishing a magazine that would deliver "objective news". If Germany was to become a democracy again, it needed a free and critical press. Much to the annoyance of the British government, the resulting magazine, *Diese Woche*, then set about criticizing the rule of the occupying powers. The team behind this title then set up *Der Spiegel* in 1947, an enduring thorn in the side of the German authorities.

DER SPIEGEL

Amerikas unsichtbare Macht

Die Aktionen des US-Geheimdienstes

CIA

1933 *Below:* Under the First Five Year Plan of 1928, the Soviet Union embarked on a series of great symbolic projects designed to industrialize the country. Published in Russian, French, English, German, and eventually Spanish, *USSR in Construction* promoted Soviet attempts to turn a technologically backward country into a highly developed and productive world power.

1923 *Right:* LEF (*Zhurnal levego fronta iskusstv), The Journal of the Left Front of the Arts,* published by the poet Vladimir Mayakovsky in Moscow, was a digest of Constructivist thinking. The montage on the cover of the second issue, designed by Aleksandr Rodchenko, stuck a symbolic line across these figures from the past.

1928 *Opposite:* Produced just before Soviet aesthetics froze under Stalin, this cover of *Krasnaya Niva (Red Field)* by painter Aleksandr Deineka depicts a central theme in Soviet culture during the 1920s, that of the New Man. Proletarian sports were encouraged as a modernizing influence on Russian society.

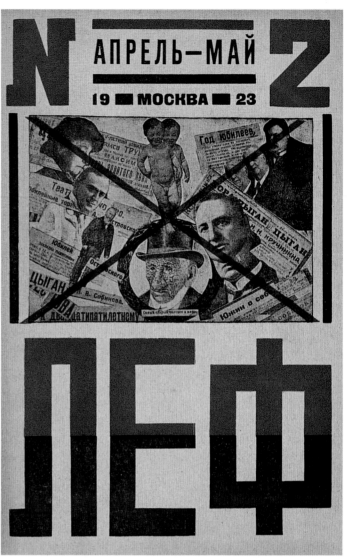

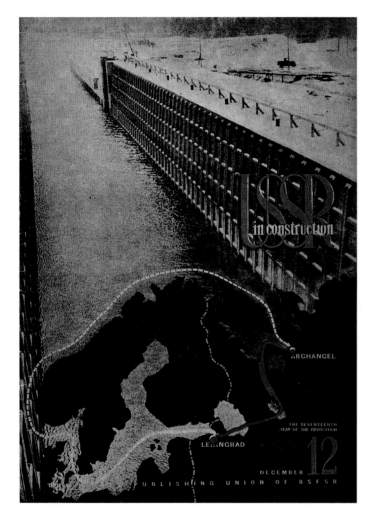

REVOLUTIONARY MAGAZINES

After the October 1917 Revolution, the Communist authorities in Russia initiated programmes of propaganda to elicit support from a largely illiterate peasant people across a vast country. Magazines were to play a key role in both teaching the people to read and proselytizing for socialism. Print also presented a means by which artists could commit themselves to the Revolution. Constructivist artists like Rodchenko turned to

photography because its mechanical character suggested modernity and its reproducibility suggested democracy. Photographic images – particularly when combined in photo-montage – would aid popular comprehension of the changes underway in Soviet Russia. While the meaning of one image in isolation might be uncertain, the combination of two images together could, in Rodchenko's words, be "the exact fixation of fact". The "truth" of an image lay not in documenting the world as it appeared, but in describing the processes and forces changing it. The hardening of political and aesthetic culture that occurred under Stalin in the late 1920s unleashed serious criticism of the avant-garde. Soviet magazines during Stalin's regime lost much of their earlier experimental character. Although the work of many members of the avant-garde of the early 1920s appeared in Stalin-era publications like *USSR in Construction* (1930–41), they now had to conform to the demand that art and design reflect working-class tastes and represent the achievements of the state.

КРАСНАЯ НИВА - 21

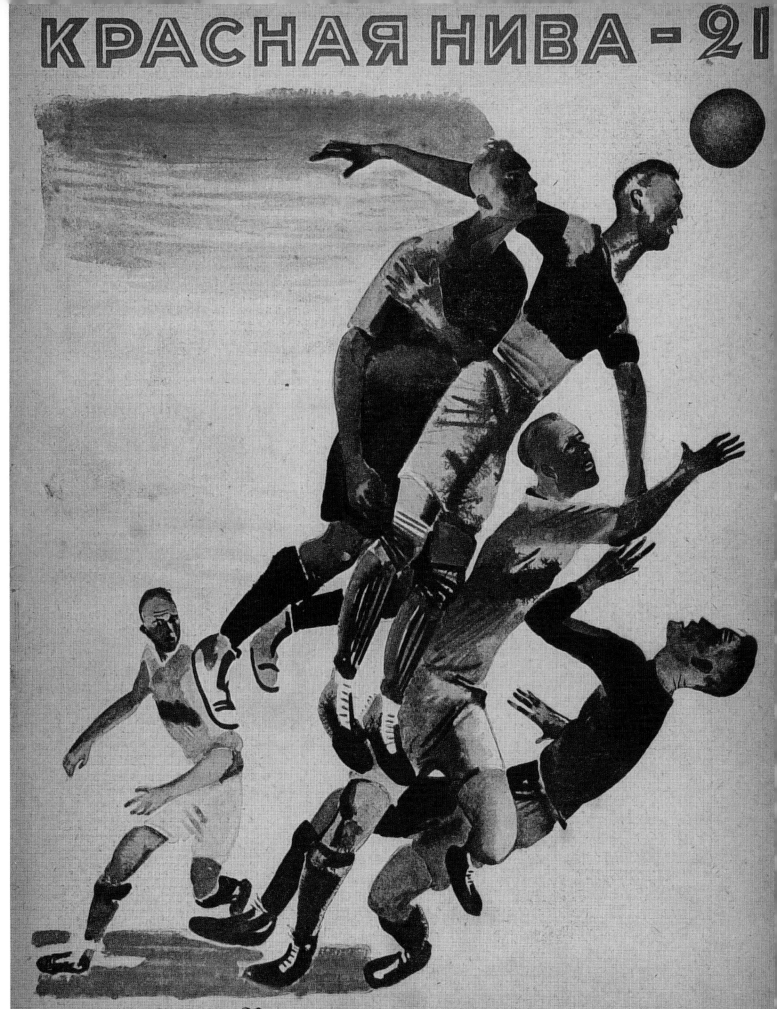

Футбол Рис. для «Красной Нивы» А. Дейнека

16. November 1930
7. Jahrgang / Nr. 46

Münchner Illustrierte Presse

Preis: 20 Pfennig
Österr.: 35 Grosch. / Tschechosl.: 2 Kron.
Schweiz: 30 Rappen / Italien: 1,50 Lire
Frankreich: 1,50 Frs. / Holland: 20 Cent
Jugoslavien: 3 Dinar

Verlag Knorr & Hirth, G.m.b.H., München

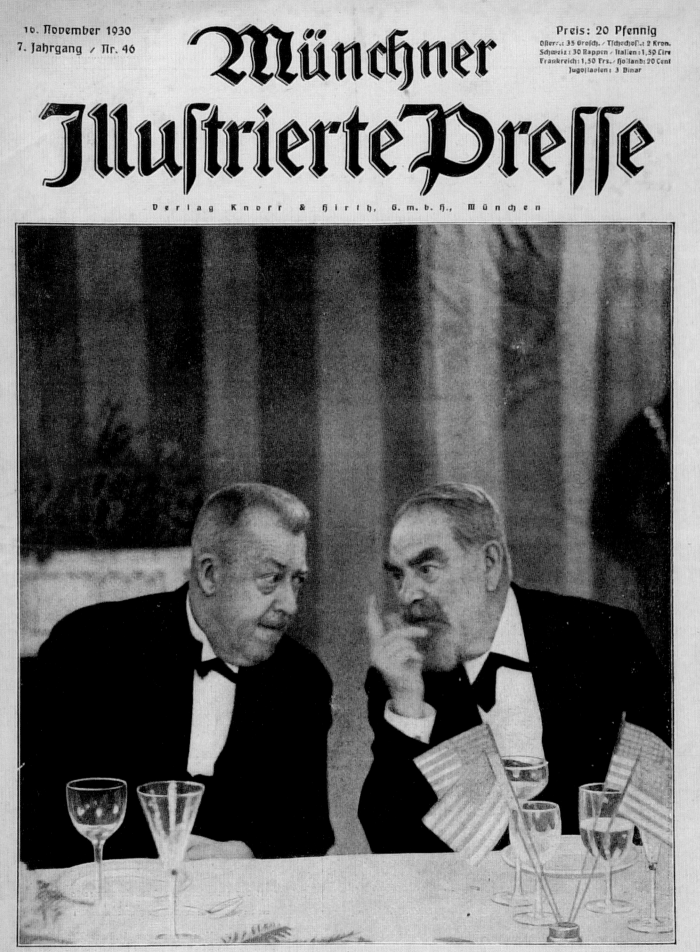

Repräsentanten deutscher Technik

Dr. Eckener und Oskar von Miller, der Schöpfer des Deutschen Museums, als Ehrengäste bei dem Festbankett der Amerikanischen Handelskammer in Berlin. Dr. Eckener gab in einer bedeutungsvollen Rede Kenntnis von seinen Plänen, für den künftigen Zeppelin unverbrennbare Heliumgasfüllung und explosionssichere Rohölmotoren zu verwenden. Anlaß zu diesen Änderungen hat die Katastrophe des englischen Luftschiffes R 101 gegeben.

Phot. Dr. Erich Salomon

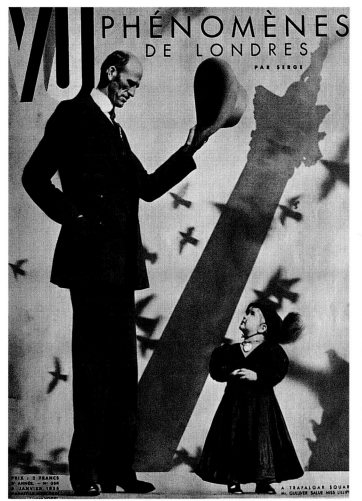

PHOTOJOURNALISM IN EUROPE

Although photographs appeared frequently on the pages of Europe's magazines in the late 19th century, a new generation of titles in the 1920s is usually credited with being the first modern photo-journals. Weeklies like the *Münchner Illustrierte Presse (Munich Illustrated Press),* which was founded in 1923, and *Vu (Seen),* published in France by Lucien Vogel from 1928, reported the social and political dramas of inter-war years in photo-essays composed by the magazines' art directors, Stefan Lorant and Alexander Liberman. Not only did these visual essays narrate events in depth, putting more of the world under scrutiny than ever before, the freelance photographers employed by *Vu* and *Münchner Illustrierte Presse* perfected the art of the candid photograph. Using small hand-held cameras, they transported the reader to inaccessible places like a diplomatic meeting or the flight deck of a Zeppelin traversing the Arctic. In Weimar Germany – a country racked by political struggles – photojournalists asserted their professional independence. One editor-in-chief wrote: "The independent photojournalist ... must be regarded as a special type of correspondent. He leaves nothing to chance

1930 *Opposite:* Erich Salomon, the photographer of this cover image of an international conference, was the master of the candid photograph. A lawyer by training, and comfortable in black tie, he blended into the background of such events.

1933–1935 *Above left:* These two covers reflect *Vu's* interest in reporting the world. Representing London, Liberman's humorous montage lends this tall man Nelson's column as a shadow. *Above right:* The faces of Spanish pilgrims are blown up to capture their absorption in prayer.

when pursuing the subject of his interest, and he seeks to present it in the best and most suitable form by means of intensive preparatory work." The value attached to autonomy was reflected in the way in which the photojournalist's images were often blown up on the cover. Under art director Alexander Liberman, *Vu's* approach to the cover was different. He regularly used photo-montage with startling effect. The significance of titles like *Münchner Illustrierte Presse* and *Vu* cannot be measured in terms of the national impact alone. They were training grounds for some of the most influential art directors and photographers of the century.

AIZ

Erscheint wöchentlich... 60 Kč, 30 Gr., 1,25 Frs., 30 Rp.
...amer. Cts., 15 holl. Cts. Jahrgang XII. - Nr. 36. - 14. September 1933.

ITSCHEN VOLKE

GOERING
DER HENKER
DES DRITTEN REICHS

In Leipzig werden am 21. September neben
dem Provokateur, Lubbe, vier Unschuldige —
Opfer eines der ungeheuerlichsten Justizver-
brechen — vor Gericht stehen. Der wahre
Reichstagsbrandstifter, Goering, wird nicht vor
den Schranken erscheinen.

Fotomontage: John Heartfield / Umschlagbild des „Braunbuchs über
Reichstagsbrand und Hitlerterror" / Das Gesicht Goerings ist
einer Originalfotografie entnommen und wurde nicht retuschiert.

SONDERNUMMER: REICHSTAGSBRAND PROZESS/GEGENPROZESS

Left: In this penetrating design connecting the burning German parliament (a stage-managed crime which the Nazis exploited to their advantage) with the Nazi Minister Hermann Goering, Heartfield, already-renowned for his skills with the scalpel, had the impudence tell the viewer that this portrait had not been touched up. The main caption reads "Goering the executioner of the Third Reich". *Opposite:* Using the Führer's own words ("Millions Stand Behind Me") and an official portrait photograph, Heartfield exposed the Nazi's reliance on capital provided by capitalists who wanted to smash the communists and trade unions in Weimar Germany.

THE *ARBEITER ILLUSTRIERTE ZEITUNG (WORKERS' ILLUSTRATED REVIEW)* WAS PUBLISHED IN WEIMAR GERMANY BEFORE THE NAZI REGIME TOOK POWER IN 1933 AND IN EXILE IN PRAGUE UNTIL 1938. As part of a German Communist Party strategy to build broad-based support, AIZ became a tremendously popular title, selling up to 300,000 copies a week in 1929 (despite the fact that the main agencies refused to distribute it). This magazine would probably have been lost in the shadows of history were it not for the remarkable photo-montages by John Heartfield that appeared on its pages. A former Dada artist, Heartfield developed a brilliantly acerbic approach to montage to attack the Party's enemies on the right and, tragically, on the left. By combining textual and photographic elements already familiar to the viewer, he punctured Nazi rhetoric as Hitler clawed his way to power in 1933 and then set about silencing his enemies.

Heartfield, as a prominent and brilliant critic of the regime, was one of its first targets. After SA stormtroopers raided his apartment in April 1933, he fled to Prague. Then in 1938, when the German authorities demanded his extradition, he flew to London, and eventually worked for British publishers.

ERSCHEINT WÖCHENTLICH EINMAL • PREIS 20 PFG., Kc 1,60
30 GR., 30 SCHWEIZER RP. • V. b. b. • NEUER DEUTSCHER
VERLAG, BERLIN W 8 • JAHRGANG XI • NR. 42 • 16. 10. 1932

DER SINN DES HITLERGRUSSES:

Motto:
**MILLIONEN
STEHEN
HINTER MIR!**

Kleiner Mann bittet um große Gaben

PICTURE POST

THE HAND OF TOIL

HULTON'S NATIONAL WEEKLY

JANUARY 10, 1948

In this issue: Dr. Hugh Dalton writes on

THE CHALLENGE OF 1948

4D

Vol. 38. No. 2

P *ICTURE POST* ESTABLISHED ITS DISTINGUISHED PLACE IN BRITISH POPULAR CONSCIOUSNESS FOR THE WAY THAT IT REPORTED THE SECOND WORLD WAR.

This large-format, photo-gravure printed magazine was established in 1938 by the Hulton Press to exploit the talents of Stefan Lorant, the art director responsible for the visual élan of the *Münchner Illustrierte Presse*. As a Hungarian-Jew and left-leaning intellectual, Lorant had been forced to flee Germany soon after Hitler's rise to power in 1933. *Weekly Illustrated*, launched in 1934, was an unsuccessful attempt to publish a British magazine based on the

German format. A few years later, Lorant's *Picture Post* was an unqualified triumph, selling 1,350,000 copies each issue within four months. The magazine's success owed much to the rapid turn of international affairs in the late 1930s. After Lorant's experiences in Germany (published in a Penguin book entitled *I Was Hitler's Prisoner*), it is not surprising that *Picture Post* took a keen interest in the growing crisis on the Continent and campaigned against the appeasement of Hitler at the time of the Munich Crisis. *Picture Post*, like all of Lorant's magazines, was assembled from photographs. Stories were commissioned from photographers rather than writers, and illustration rarely

1935 *Left*: This bold portrait of an African soldier fighting for Mussolini in Libya was for the cover of *Weekly Illustrated* in October 1935.

1940 *Above*: This July 1940 cover, designed by Stefan Lorant, used his trademark device of visual comparison to press the point that Nazi Germany was an aggressive, militaristic society.

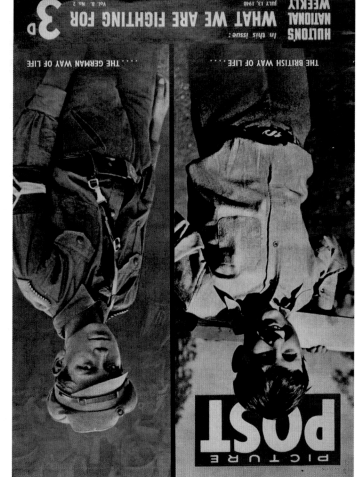

1948 *Opposite*: The daunting task of rebuilding a war-damaged country was symbolised by this powerful photograph of working hands on a January 1948 cover.

1948 *Left*: Published late in the war, this cover shows Private Billings with the Belgian family that offered him shelter while the remaining German forces in the region were pacified.

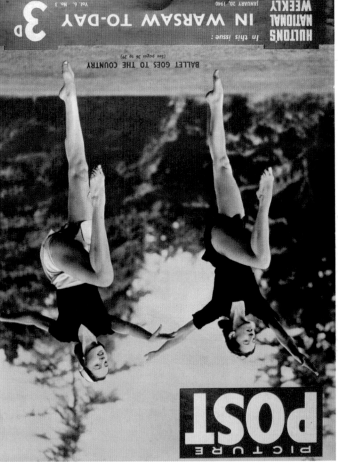

1940–1953 *Below left:* Reporting ordinary life in war-time, this issue covered the evacuation of London ballet schools to the British countryside. The photograph captures the arrested movement of the dancers. *Below right:* This March 1946 cover by Gjon Mili uses multiple-exposures to capture a quick-drawing FBI agent. *Opposite:* The fantasy of science fiction had more appeal than the austere realities of British post-war life.

appeared on its pages. As the covers here show, photographs could communicate powerful and sincere messages without extensive textual explanation. Lorant (who left London in 1940 fearful of invasion) made good use of his European contacts, commissioning a number of prominent émigré photojournalists including Kurt Hutton, Felix Man, Tim Gidal and Robert Capa. The great success of the magazine during the Second World War and in the period of immediate post-war reconstruction has been

put down to what Stuart Hall has called its "social eye". Recognizing the great sacrifices that ordinary people were making on the home front and in the forces, *Picture Post* addressed its readers as intelligent and concerned participants in the events recorded on its pages. Unlike government propaganda produced at the outset of the conflict, this meant representing tragedy and hardship as well as courage and victory. *Picture Post* also focused on post-war British society, and ran articles arguing for government investment in housing, health and social security. As the magazine entered its second decade, Britain was changing in ways

that its editors found hard to accommodate. While the magazine's social eye had been well served by powerful photographic realism during the 1940s, gritty images and an earnest, campaigning tone were ill suited to an age of consumerism. The arrival of commercial television, hire purchase, pop music and the growing appeal of what its journalists liked to call "the American way of life" has been credited as bringing about the magazine's downfall. Although it shifted its focus slightly to include Hollywood stars, it lost sales to magazines like *Reveille*, which offered its readers pin-ups and celebrity gossip. Poignantly, its last cover in 1957 was an identical copy of its first.

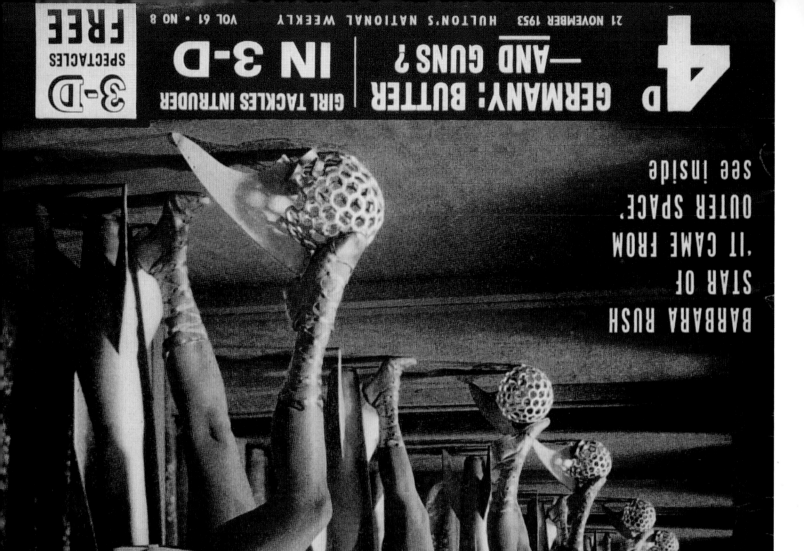

21 NOVEMBER 1953 · HULTON'S NATIONAL WEEKLY · VOL 61 · NO 8

4d

3-D SPECTACLES FREE

GERMANY: BUTTER
—AND GUNS?

GIRL TACKLES INTRUDER
IN 3-D

BARBARA RUSH
STAR OF
'IT CAME FROM
OUTER SPACE'
see inside

PICTURE POST

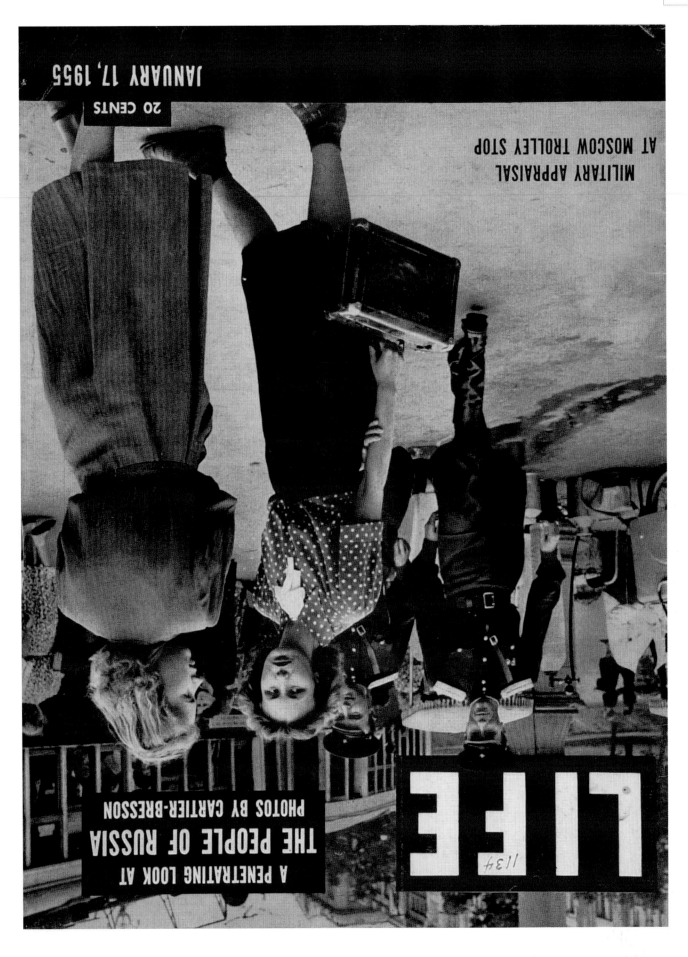

MILITARY APPRAISAL
AT MOSCOW TROLLEY STOP

JANUARY 17, 1955

20 CENTS

A PENETRATING LOOK AT
THE PEOPLE OF RUSSIA
PHOTOS BY CARTIER-BRESSON

LIFE

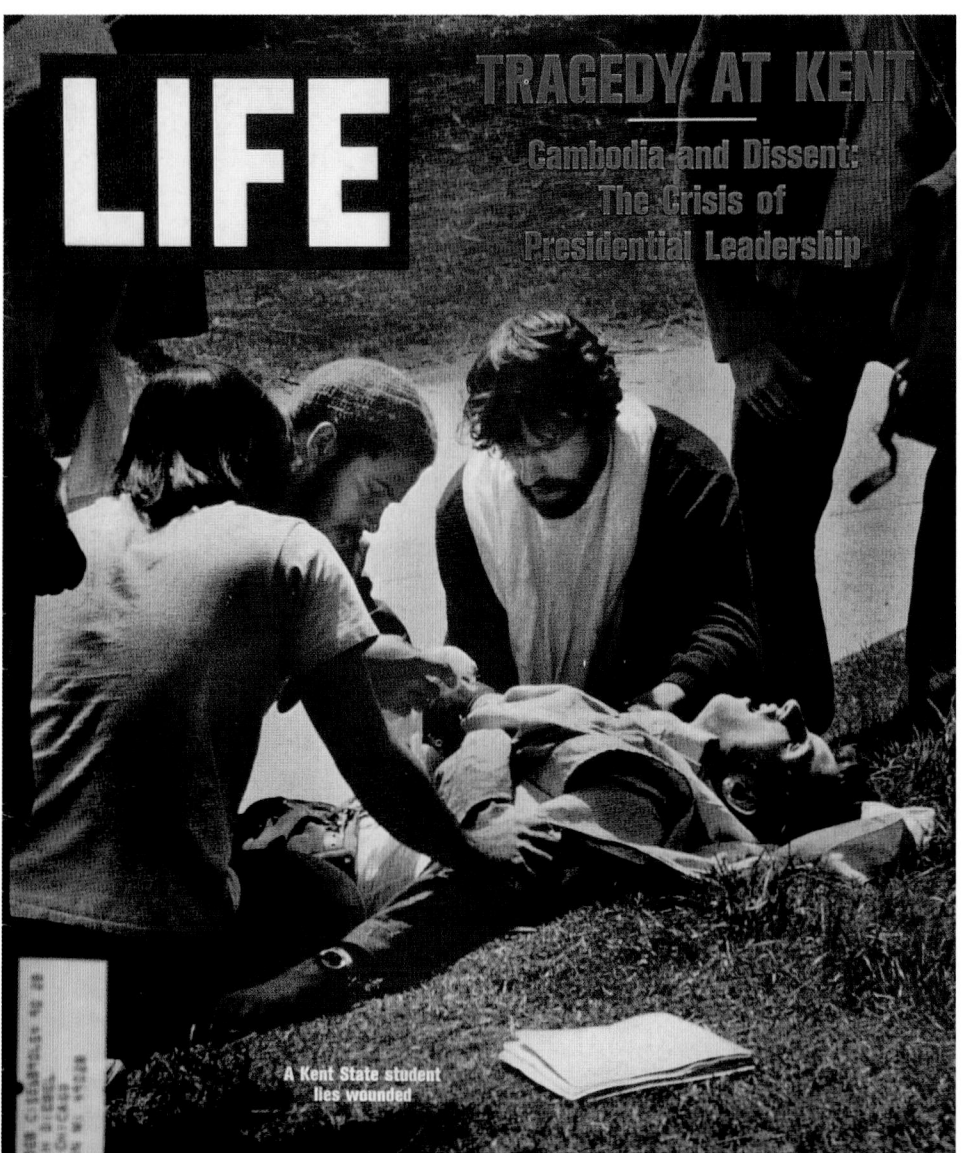

LIFE

TRAGEDY AT KENT

Cambodia and Dissent:
The Crisis of
Presidential Leadership

A Kent State student
lies wounded

MAY 15 · 1970 · 50¢

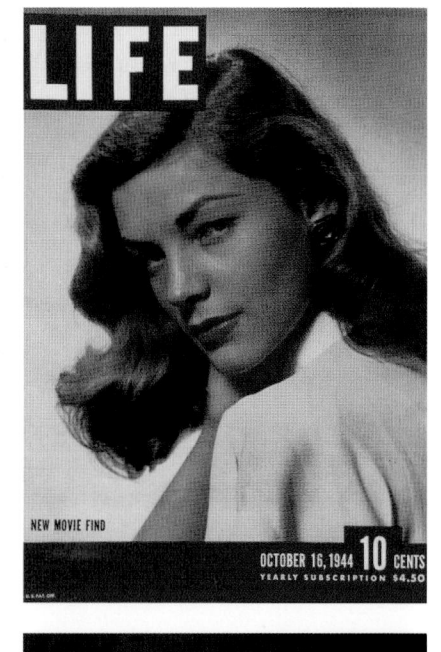

LIFE

NEW MOVIE FIND

OCTOBER 16, 1944 **10** CENTS
YEARLY SUBSCRIPTION $4.50

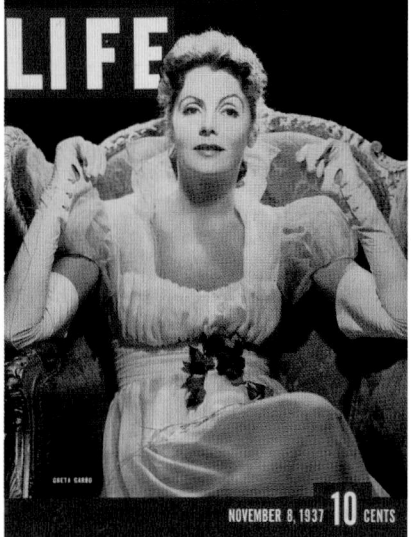

LIFE

GRETA GARBO

NOVEMBER 8, 1937 **10** CENTS

*L*IFE – A WEEKLY NEWS MAGAZINE PUBLISHED IN AMERICA BETWEEN 1936 AND 1972 – REPRODUCED MANY OF THE MOST POWERFUL AND EMOTIVE IMAGES OF THE 20TH CENTURY ON ITS PAGES. Many have become popular icons, summing up the dramatic events which they record. *Life's* best cover images captured events "from the inside", reporting the tragic effects of conflict on individuals or the ordinary pleasures of everyday life. Like the Central European magazines on which it was based (see pages 62–63), *Life* privileged the image over the word in long photo-essays. The roster of photographers whose work graced its pages is a roll call of the greatest talents in the field and includes Robert Capa, Henri Cartier-Bresson and W Eugene Smith. Although *Life* was revived as a monthly title in 1978, it never regained its high place in American culture. Like *Picture Post* in Britain, it could not compete with the rolling waves of specialist titles that delivered valuable niche markets to advertisers. While photographers continued to acknowledge the prestige of appearing in *Life* even in its last years as a weekly, as publisher Don Logan stressed: "*Life* didn't have a core of advertisers that had to be in *Life* every issue".

1937–1970 *Opposite:* Following Stalin's death in 1953 American relations with the USSR improved. In the spirit of rapprochement, *Life* featured this charming image by Henri Cartier-Bresson. The Russian soldier was represented in terms of ordinary and universal interests. *Above left:* When the Vietnam War escalated with the invasion of Cambodia, protests formed across the country. At Kent State University in Ohio, the National Guard fired live ammunition at a student demonstration. Howard Ruffner captured the tragedy that left four dead. *Life's* art director cropped his photograph to heighten the drama of this event. *Above:* Hollywood stars Greta Garbo and Lauren Bacall appeared as cover stars in 1937 and 1944.

FIRST PUBLISHED BY JOHN JOHNSON IN 1945, *EBONY* WAS THE MOST IMPORTANT MAGAZINE SERVING AFRICAN-AMERICAN READERS OF THE POST-WAR PERIOD.

Closely following the format of *Life* magazine – even down to adopting its striking red and white masthead – it featured

large photo-spreads and in-depth features on America's black stars in the fields of entertainment, sport and business. *Ebony* reflected the rise of black Americans in public life as well as the growing consumerism of its largely middle-class readership. Despite its success in attracting readers,

Ebony faced problems attracting advertisers, a financial lifeline for most titles. Unlike many of the consumerist American titles of the period which reflected the self-satisfaction of what economist JK Galbraith criticized as "The Affluent Society", *Ebony* took on a campaigning attitude in

the 1960s. It reported the Civil Rights movement, which argued for the end of legalized segregation of the races, as the covers here illustrate. In the 1970s the magazine shifted emphasis, stressing the rise of Black corporate America, heralded by the rise of Berry Gordy's Motown in the 1960s.

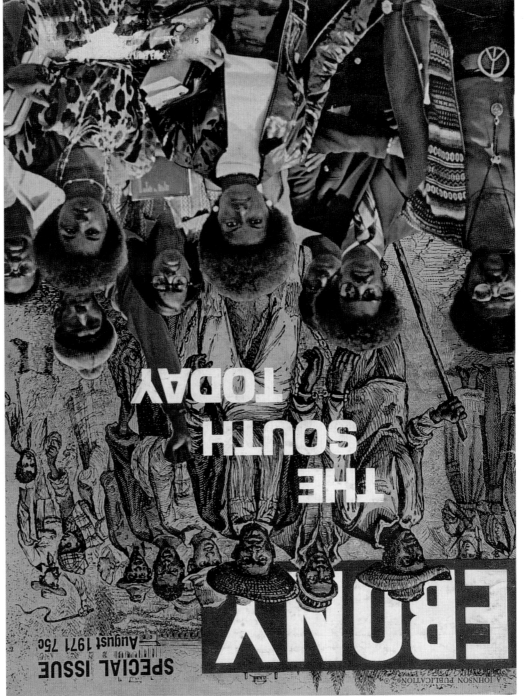

1969–1971 *Left*: Civil Rights protesters had struggled hardest against discrimination in the southern states of America. This cover, designed by Herbert Temple, contrasts black slaves with university-enrolled students to represent black achievement. The raised arm of the white plantation overseer holding a whip is powerfully contrasted with the raised fist of the black activist below. *Above*: Motown act The Jackson Five were about to launch around the world through an animated TV cartoon when they appeared on the cover of *Ebony* in 1971. *Opposite*: Herbert Temple's cover image was described by the editors of *Ebony* in 1969 as a symbol of "black identity and inner strength which rules out forever a return to that traditional brand of race relations that characterised the lives of their elders".

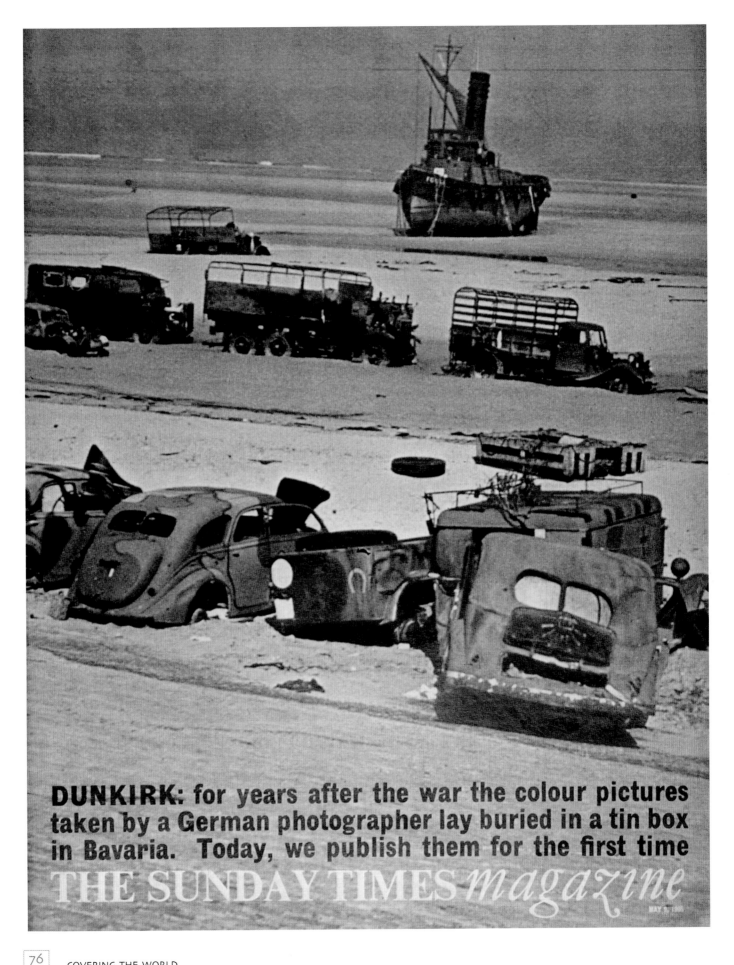

DUNKIRK: for years after the war the colour pictures taken by a German photographer lay buried in a tin box in Bavaria. Today, we publish them for the first time

THE SUNDAY TIMES *magazine*

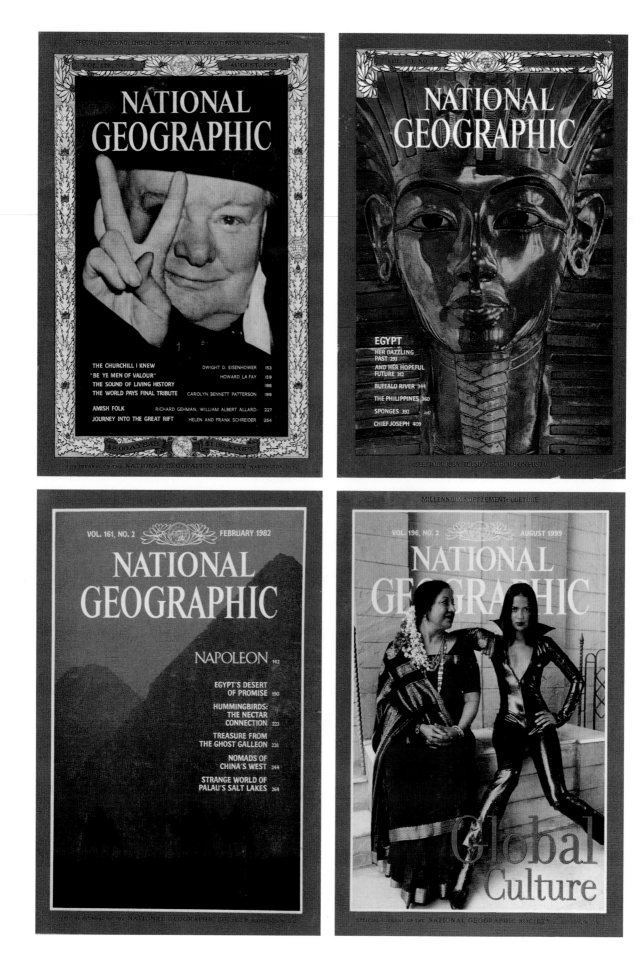

THE NATIONAL GEOGRAPHIC MAGAZINE WAS LAUNCHED IN WASHINGTON, DC IN 1888 BY THE NATIONAL GEOGRAPHIC SOCIETY IN A BID TO IMPROVE ITS FORTUNES. Early issues were rather poorly illustrated with little more than graphs. President of the Society Alexander Graham Bell saw its future success in terms of "more dynamical pictures – pictures of life and action-pictures that tell a story". Under editor Gilbert Hovey Grosvenor, the magazine realized Bell's vision. It became a phenomenally successful title (with over 1 million readers by the 1920s) largely as a result of the beautiful colour images of plants and animals that appeared on its pages.

A very committed amateur photographer whose images have been rediscovered in recent years, Grosvenor firmly believed that "geography could be fascinating, if told simply, accurately, and if fully illustrated". His words are still a guiding principle today.

The evolution of the cover – represented in the images spanning nine decades here – reveals the magazine's origins as a scholarly publication. Despite its interest in technical developments in photography (which included its own processing labs), the magazine maintained the conservative format of a contents list framed by a classical border in the inter-war years. As the cover image grew in significance, the border receded. Today, it features as a spectral device above the masthead. While the beautiful photographs that appear often attract enviable comment from other sections of the media, the February 1982 issue provoked much controversy. In an early example of digital retouching, the pyramids in Egypt were "recomposed" on screen. Gordon W Gahan's evocative landscape photograph was made to fit the vertical cover format by "moving" the pyramids closer. Although retouching was not a new practice, this excited comment because of the magazine's reputation as a reliable and scientific publication.

1928–1999 *Below left:* A 1928 cover displays the magazine's scholarly origins. *Below right: The National Geographic Magazine* concept of geography was expanded by the Space Race of the 1950s and 1960s. *Opposite top left:* A portrait of former British prime minister Winston Churchill featured on the cover of an issue commemorating his life in 1965. *Top right:* A 1977 cover makes use of one of the most widely-reproduced images of the decade, the mask of Tutankhamun in the Egyptian Museum in Cairo. *Bottom right:* Itself a global brand, this 1999 issue reflected the controversial theme of globalization through Joe McNally's photograph of a fashion model with her mother wearing traditional dress from Bombay. *Bottom left:* Gordon W. Gahan's controversial photograph featured on the cover of the February 1982 issue.

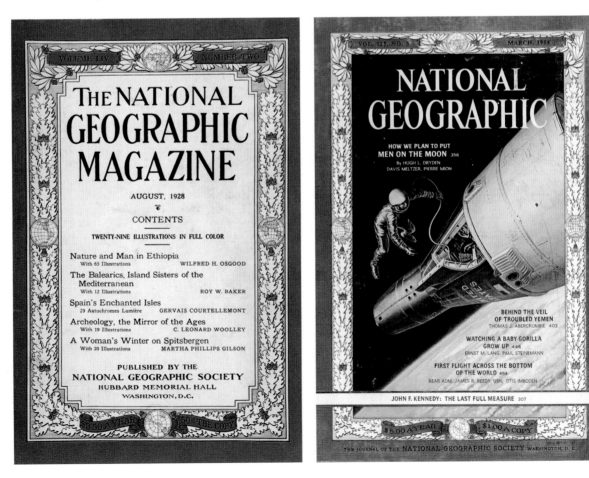

A JOHNSON PUBLICATION ®

EBONY

THE
BLACK
REVOLUTION

AUGUST 1969 60c

SPECIAL ISSUE

THE SUNDAY SUPPLEMENTS

In 1985, looking back at his career, Mark Boxer, the Sunday Times colour supplement's first editor, said: "Newspapers are about the world out there: an objective and masculine world, gritty and grey and above all immediate. Magazines at their best are more seductive, intimate and subjective. They are instant nostalgia, almost your autobiography in advance." Not only were the newspapers that the first supplements accompanied in the early 1960s monochrome: British life seemed to be drab and austere too. The new wave of "coloursups" promised drama, excitement

and, above all, change. The first issue of The Sunday Times Magazine, published in 1962, included a feature on Mary Quant, clothes modelled by Jean Shrimpton, and photographs by David Bailey, as well as, of course, glossy advertising. Despite their interest in the seductive world of consumerism, celebrity and art, the magazines of the late 1960s also achieved renown for their hard-hitting approach to news events such as the Vietnam War. But their kaleidoscopic mix of celebrity and news also came under attack. Art critic John Berger asked in the early 1970s what effects would publication of celebrations of the mini skirt and Formica side-by-side with features on poverty and war have on the reader.

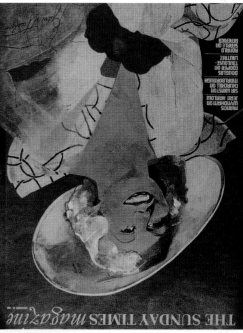

THE SUNDAY TIMES *magazine*

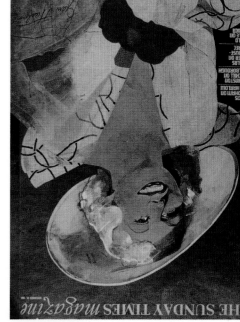

THE DAILY TELEGRAPH MAGAZINE

1970 Left: Reviewing the "Violent Decade" of the 1960s, The Daily Telegraph Magazine featured Magnum photographer Philip Jones Griffiths' tragic image of an injured child in Vietnam on its cover.

1964 Above: The sharp tonal contrasts in George Silk's dramatic photograph of a skier allowed the designer of the Weekend Telegraph to reverse the masthead.

WEEKEND TELEGRAPH

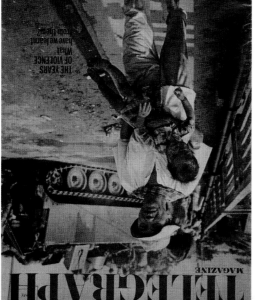

THE DAILY TELEGRAPH MAGAZINE

VERUSCHKA AND HER DESERT BIKINIS

Number 193 June 21 1968

1964 Below: Pop artist Peter Blake's portrait of film star Jean Harlow exaggerated her trademark white hair and plunging necklines.

1968 Right: Supermodel of her day and famous for her appearance in Antonioni's film Blow Up, Veruschka von Lehndorff was photographed in the North Sahara by Franco Rubartelli.

1965 Opposite: Reflecting its commitment to colour photography, this ostensibly drab image offered an unexpected view of Dunkirk in 1940, an event which in the British consciousness had been recorded in monochrome images of the evacuation of Allied troops. It had been taken by Hugo Jaeger, a photographer attached to the German High Command.

COVERING VIETNAM

The Vietnam War was fought before the world's media. Photographers and journalists were given a remarkable degree of freedom by the American authorities to report its battlefields (with over 650 covering the war on the ground at the height of the conflict). The American public's growing worries about the merits of prosecuting the war (which eventually compelled the Nixon government to withdraw American forces in 1973) has been widely viewed as an effect of their words and images. America's campaign to stop the advance of communism in Indo-China had intensified through the course of the 1960s. By 1968 America was deeply involved in a vicious and confusing conflict, deploying over half a million troops. While the media at first expressed support for American involvement (even to the extent of refusing to send back the most gruesome images for domestic consumption), the waste of lives and destruction of a poor, largely peasant country changed many minds. As the war ground on, photo-journals like *Life* and news magazines like *Time* recorded the daily tragedies of war in graphic detail. Anti-war protest became a staple theme in counter-culture magazines like *Oz*. Eddie Adams' photograph of the highest ranking general of the anti-communist South Vietnamese forces executing a Vietcong suspect without trial became a symbol of injustice. Widely reproduced in the mainstream news media, *Oz* designer Martin Sharp captioned it with the words "The Pornography of Violence". This was not only an indictment of American foreign policy but of a culture that found glory in conflict.

1965 *Right:* In the early days, *Life* reported the building conflict in matter-of-fact terms. Photographer Mark Kauffman captured both the swagger and the unease of young servicemen conscripted into the American forces on this cover.

1966 *Far right:* Henri Huet's moving photograph appeared widely in the American news before being adopted for the cover of *Life*. It depicts a young American medic, blinded in one eye, who stayed at his post caring for the combatants despite his own injuries.

1969 *Opposite:* This photographic grid composed by Norman Gorbaty combined a portrait of President Nixon, a notoriously vexed figure, with images of the conflict and the Moratorium Day protests.

1968 *Below:* Martin Sharp's cover of *Oz* offered a powerful comment on "the Great Society" and its fascination with violence.

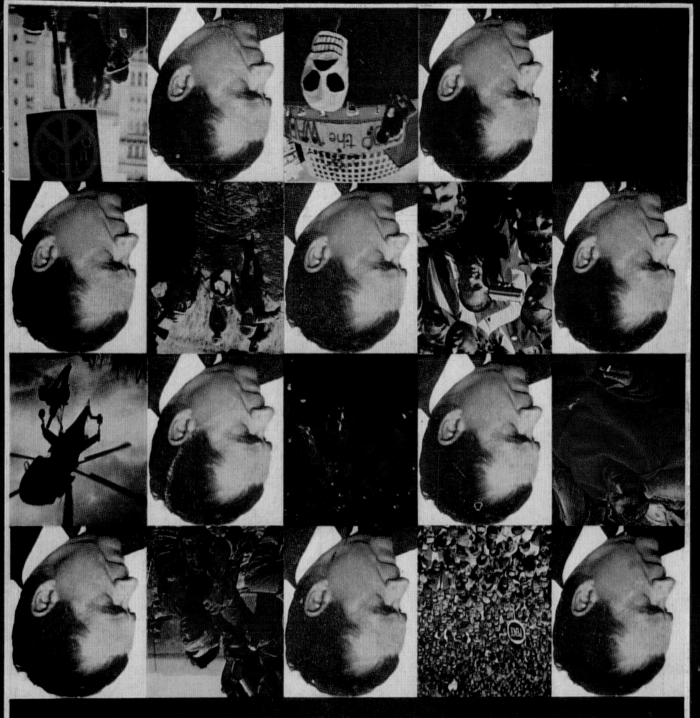

WHAT IF WE JUST PULL OUT?

1969–1970 *Opposite:* The famous "Female Power" (aka "Cunt Power") issue of *Oz* was edited by the feminist writer Germaine Greer. *Left:* "Yippie" *Oz* depicts a gun-toting family of urban guerrillas with the ironic legend: "He drives a Maserati/She's a professional model/The boy is the son of the art editor of *Time* magazine/Some revolution!"

1971 *Below:* Renowned for its enthusiastic coverage of matters sexual, the editors of *It* often drew upon soft-porn and naturist images such as the one that appeared on the December cover. They maintained a distance from such imagery by captioning their covers with ironic injunctions.

THE UNDERGROUND PRESS

The counter-culture of the late 1960s was home to a diverse range of interests – from hippies interested in transcendental drugs to Black Power militants prepared to take up arms to fight injustice. Underground magazines like *Oz* and *It* (known as *International Times* until *The Times* newspaper forced a change of name) were founded in London in 1966 to represent opinions and ways of life that did not find expression in the mainstream media. Committed to libertarianism, the editors of counter-cultural magazines sought to test the social conventions of the day. *It* regularly featured images of nudity filched from pornographic and naturist publications. *Oz* went further, publishing a notorious "schoolkids" issue in 1970 that led to the editors being prosecuted for publishing "obscene" material drawn and written by teenagers. Underground magazines like *Oz* were aware of the pitfalls of success. With sales doubling and trebling when they covered the nascent rock culture being formed at events like the Isle of Wight festival in 1970, more commercially minded publishers saw the market value of "radical chic". Titles such as *Rolling Stone* displayed much of the Underground's style and relinquished much of its politics. Yet success did not always mean selling out. *Spare Rib,* the influential feminist magazine, was founded in 1972 by active figures in the Underground (see pages 84–5).

THE LINDSAY GAME:
Three Tracks to the Presidency

40 CENTS DECEMBER 1, 1969

NEW YORK

ATTENTION NEW YORK YOU DON'T HAVE TO LIVE THIS WAY... THERE'S THIS PLAN...

GUERRILLA GUIDE FOR THE CONSUMER

NEW YORK

SPECIAL YEAR-END ISSUE

GUERRILLA GUIDE FOR CONSUMERS
BONUS 12-PAGE HANDBOOK
FEATURING COMPLETE INSTRUCTIONS FOR
HOW TO BREAK THE SUPERMARKET CODE
AND GUARANTEE YOUR FOOD IS FRESH

Net Weight 6 oz.

The magazine that tells you what's on and where to go in London.
February 15-21 1980 No.513 35p

Time Out
Heroin £120

The blackest market. As prices are slashed,
we look at the causes of London's heroin epidemic.

1969–1970 *Left: New York* often sought to speak for its readers on matters of common interest by protesting against exploitation and urban decay. James McMullan's cover illustration introduced a series of articles reflecting on the *Plan for New York*, published in 1969. Milton Glaser's lively masthead lettering was incorporated into this ersatz packaging for an issue on consumer protest.

1973–1980 *Opposite and below:* Pearce Marchbank's cover designs for *Time Out* from the 1970s were invariably succinct graphic statements, produced under the constraints of a weekly deadline. Eschewing publicity material on offer from the entertainment industry, Marchbank, with photographer Mick Brownfield and illustrator Peter Brooks, responded to events in the British capital with vision and economy.

TALES OF NEW YORK AND LONDON

As titles like *The Illustrated London News* and *The New Yorker* reveal, magazines are urban products. Not only serving the city, some have sought to change it. In 1968 both London and New York enjoyed new magazines that took a campaigning attitude. *Time Out* was first issued as a listings sheet by publisher Tony Elliott, but its trademark "typographic halo" and graphic covers did not appear until Pearce Marchbank joined two years later. Originally a supplement to a newspaper, *New York* appeared as a small-scale weekly. Redesigned by prominent American designer and illustrator Milton Glaser, it was widely praised for an imaginative use of cover illustration on topical themes.

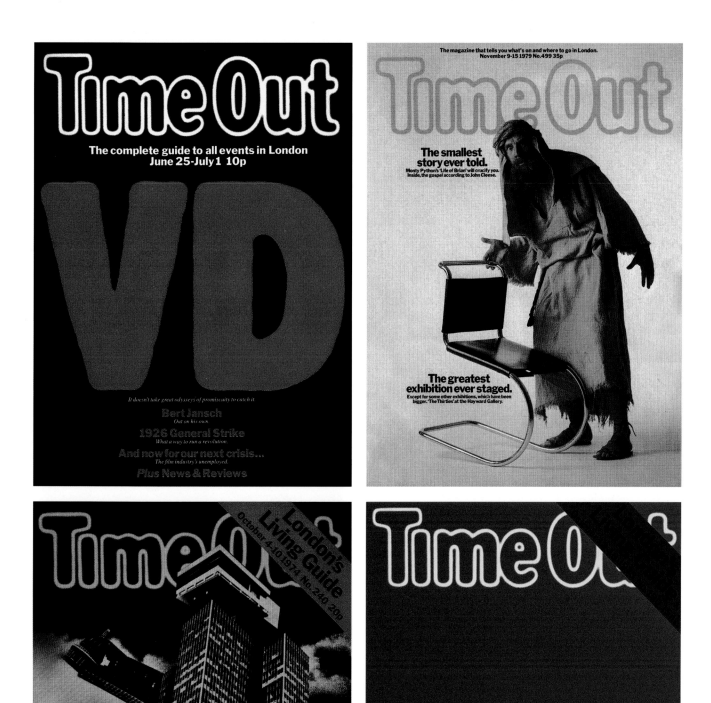

1977–1982 *Above (left to right):* July 1977 issue employing an international feminist symbol; February 1982 cover, a pastiche of a copy of *Picture Post* from the late 1940s, commenting on the failure to overcome racism in Britain; July 1978 cover illustration by Lucy Williams. *Right:* September 1982 cover with a caricature of Wonder Woman.

SPARE RIB WAS FOUNDED IN LONDON IN 1972 BY ROSIE BOYCOTT AND MARSHA ROWE. BOTH HAD WORKED FOR UNDERGROUND MAGAZINES.

Although feminist politics had been given an airing in magazines like *Oz*, it had been compromised by the underground's hedonism ("free love" had been a slogan that did little to improve the economic or social status of women). In fact, more than one contributor to *Oz* has suggested that the way in which women contributors were treated by the underground magazines had shaped their resolve to set up their own women's titles. At the same time most mainstream women's magazines eschewed politics. *Spare Rib*, a campaigning monthly, sought to fill this space by tackling "public" issues like equal pay and "private" ones like beauty with equal vigour. The counter-cultural credo of the late 1960s that the "personal is political" motivated the magazine through ups and downs for more than two decades.

Although produced on a shoestring budget and maligned for lacking colour both in terms of its appearance and tone, the magazine's producers paid increasing attention to cover design. But the cover was not just competing for sales; it was a weapon in a struggle with its neighbours on the news-stand. Many feminists argued that images of women in advertising and in the mainstream press contributed to their marginalization. *Spare Rib*'s illustrators and artists frequently employed parody to mock the catalogue of stereotypes paraded in the mainstream media. The July 1978 cover reproduced here asked, "Who do you think you're looking at?" The magazine's combative tone was, however, a major factor in its downfall. According to Eileen Fairweather, who worked on the magazine in the 1970s, readers felt harangued rather than engaged by its articles. And Rosie Boycott, today a prominent journalist, recalled "I started to argue with *Spare Rib* ... we had a lot of fun in our lives and there was a failure to communicate any of this through the magazine." Nevertheless *Spare Rib* must be regarded as an important attempt to change the culture of women's magazines.

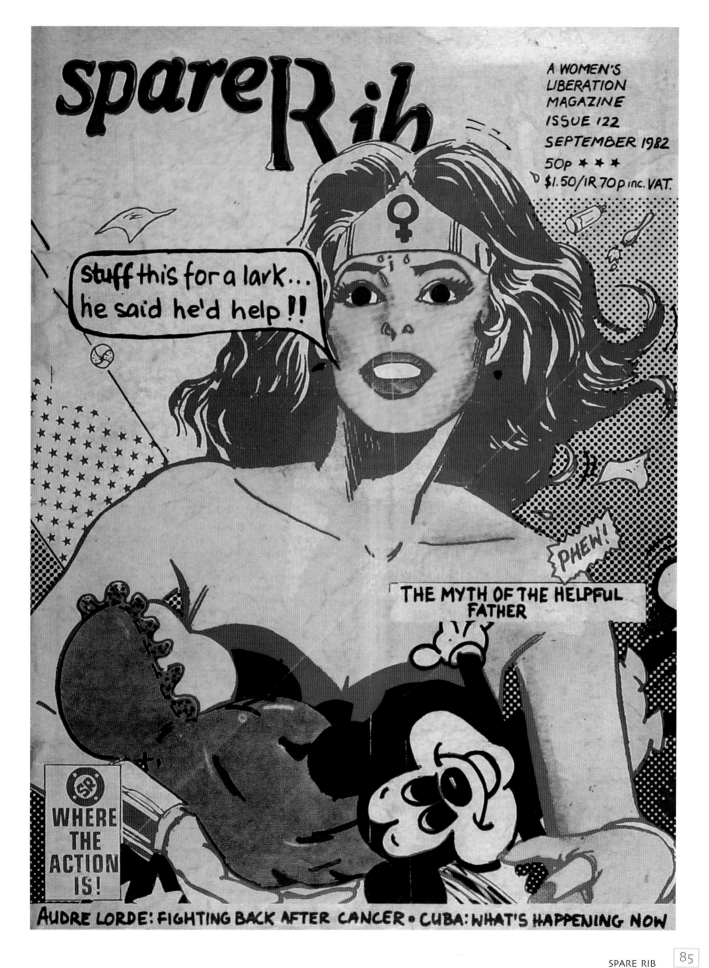

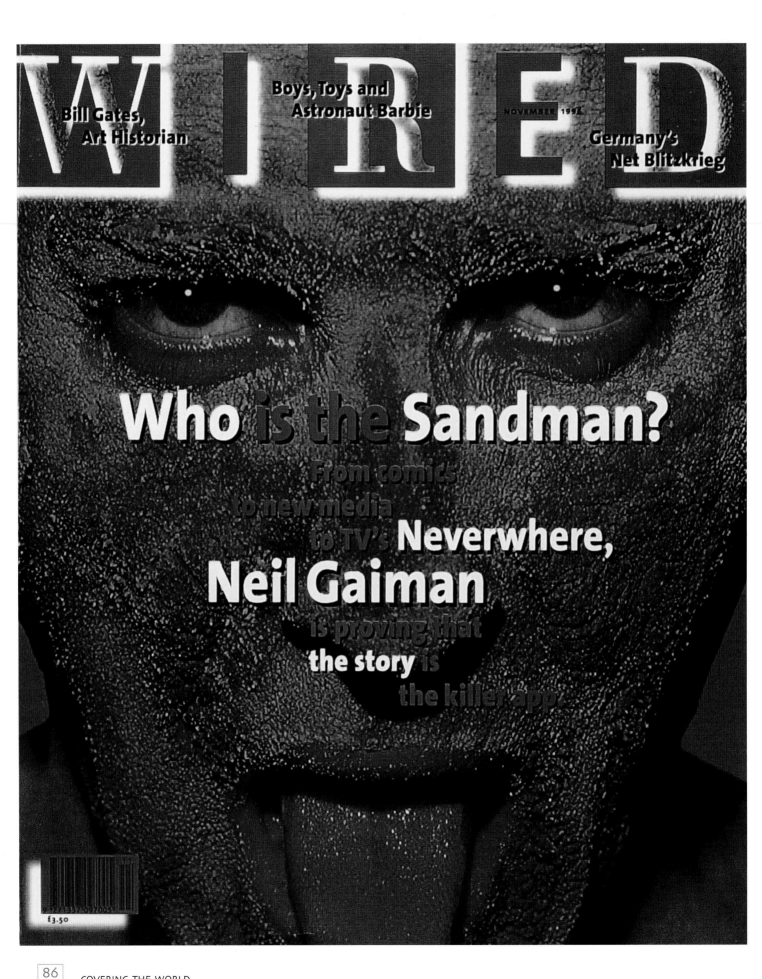

WIRED

Bill Gates, Art Historian

Boys, Toys and Astronaut Barbie

NOVEMBER 1996

Germany's Net Blitzkrieg

Who is the Sandman?

From comics to new media to TV's **Neverwhere, Neil Gaiman** is proving that the story is the killer app

£3.50

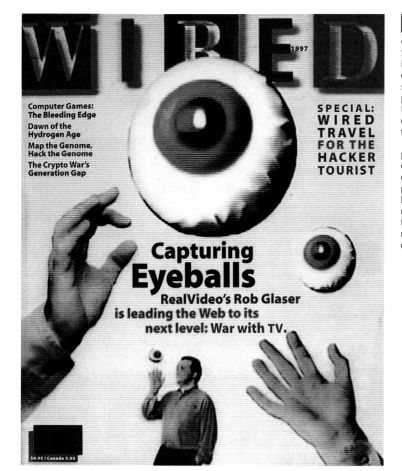

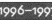

Computer Games:
The Bleeding Edge
Dawn of the
Hydrogen Age
Map the Genome,
Hack the Genome
The Crypto War's
Generation Gap

SPECIAL:
WIRED
TRAVEL
FOR THE
HACKER
TOURIST

Capturing Eyeballs
RealVideo's Rob Glaser
is leading the Web to its
next level: War with TV.

$4.95 / Canada 5.95

1996–1997 *Opposite:* Rather than reproduce original artwork from Neil Gaiman's Sandman series of graphic novels to illustrate the lead article, the UK edition of *Wired* commissioned this self-consciously grotesque image from photographer Steve Double. *Left:* Karen Moskowitz's montage appeared on both the front and back covers of this issue of *Wired*. Recognising *Wired's* aesthetic investment in powerful images, vodka-maker Absolut commissioned Moskowitz to produce one of her enigmatic images for a back-page advertisement. *Below: Wired* broke with convention when it reproduced a detail from a Norman Rockwell painting representing the rights and vision of the common man on its cover.

WIRED TOOK THE LEAD IN REPORTING THE DEVELOPMENT OF DIGITAL TECHNOLOGIES AND THE PHENOMENAL GROWTH OF THE INTERNET.

Writer Gary Wolf recalled the production of the first issue in San Francisco in 1993: "The staff had a strange confidence, even a fanaticism, and soon the first fluorescent and brightly metallic pages came off the printer. They had made a magazine in the form of a manifesto." With roots in the community of hackers and technophiles, *Wired* has always maintained a critical approach to the exploitation of cutting-edge technology by business, despite the magazine's own commercial success. Alongside sometimes breathless reporting of the far-reaching possibilities of new media, *Wired* has also maintained a strong, libertarian commitment to freedom of expression and the rights of citizenship in cyberspace. Eschewing product shots and celebrity portraits, *Wired's* covers usually present eye-catching images symbolizing the effects of new technologies (quite literally in the cover above). Highly saturated colour has become the trademark style of the magazine's cover. Not only unmistakable, the covers also capture the hyper-real qualities of the digital image. Investigating a world where photographs are not made by the operation of a shutter and a lens but are composed on a computer, *Wired* takes on the conventions of perception.

The
Digital Citizen:
The Surprising
Results of the First
In-Depth Survey

What we really
want from Santa:
Gear We Need
Kevin Kelly talks
to Tom Peters
Sex Sells!
by Frank Rose

$4.95 / Canada 5.95

DESPITE ITS CONTINUED SUCCESS, *COLORS* REMAINS AN ANOMALY ON THE NEWS-STAND. Deriving its name from the slogan, "The United Colors of Benetton", this magazine owes its existence to the cultural aspirations of the Italian clothing manufacturer. *Colors* has been closely connected to the company's advertising campaigns of the 1990s, often sharing Oliviero Toscani's startling images of life, sex and death. Yet the magazine content is free of Benetton's control. The editor-in-chief of *Colors* in the mid-1990s, Tibor Kalman, responded to claims that the magazine was a form of indirect and duplicitous advertising by stressing his own interest in using the magazine to encourage readers to be critical and doubtful of the world of images. Kalman saw it as a way of "challenging assumptions about what a magazine might be". *Colors* has maintained a thematic approach to content at odds with that of the conventional glossies, which are niched to serve a particular market. An issue of *Colors* dedicated to travel might, for instance, be followed by another on AIDS. Underlying this strategy is a loosely political philosophy which stresses that, while the needs and interests of people are shared across the globe, resources are not. In an age where most magazines are tightly niched to serve narrow interests and specialist markets, *Colors* remains an exceptional publication. As the slogan above its masthead claims, it sees its readership and its effects in global terms.

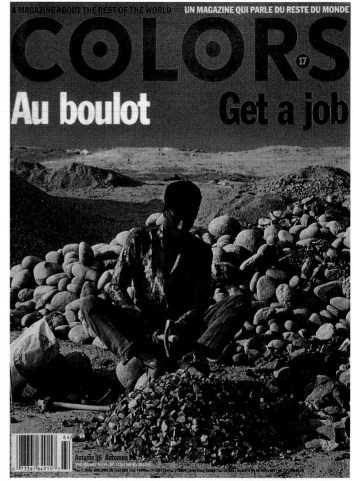

1996–2002 *Top right:* The Bangladeshi stone-breaker on the cover of *Colors 17* dedicated to the theme of work might be mistaken for a prisoner condemned to hard labour. *Bottom left:* Travel, the theme of *Colors 49* – containing reflections on bungee jumping, sex tourism, and drug trafficking – is introduced through this modest image of a racing pigeon; *Opposite: Colors 23* took the theme of the family. Although unaffected and direct, the cover image of a condom was a provocative comment on this topic by Toscani and art director Adam Broomberg.

a magazine about the rest of the world una rivista che parla del resto del mondo

CO⊙LOR⊙S 23

**GIFTS FOR THE FAMILY
REGALI PER LA FAMIGLIA**

Novembre - Dicembre '97
November - December 97

Spec. in A.P. 45% - ART.2 C20/B L.662/96 VERONA Aus 7.50A$ | BRD DM9.50 | Can 8C$ | Esp 700Ptas | Fr 32FF | Hellas 1700DR | Hong Kong HK$70 | Ital L.6.000 | Neder1 9.95 FL | Switz 8SF | UK £4 | USA $6.50

70023

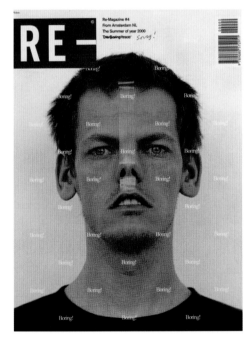

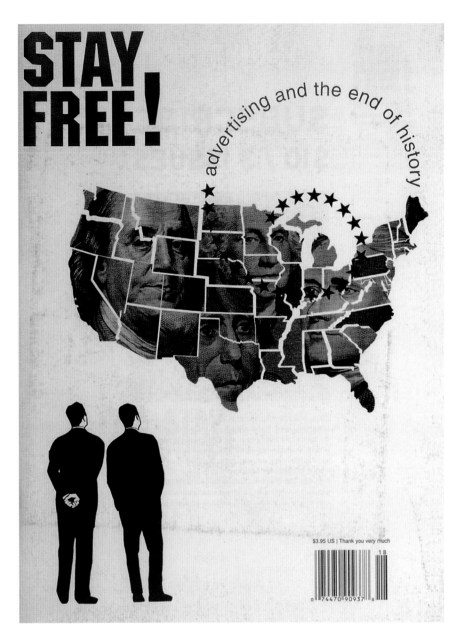

PROTEST

2001 *Opposite: Adbusters,* a bi-monthly Canadian magazine, has been a significant channel of anti-consumerist sentiment, sponsoring boycotts of controversial goods and promoting the practice of "subvertising" – the ironic reworking of brands and advertisements. The September 2001 issue was designed by Jonathan Barnbrook, a prominent British typographer and graphic designer. Barnbrook makes comment on the way that advertising shapes magazine publishing by reproducing a Rimmel lipstick advertisement obscured by the scrawl of a marker pen as the cover.

2000–2001 *Above: Re,* a magazine produced by Jop van Bennekom in Amsterdam, offers an oblique critique of the consumer society. The "Anti-attitude" (top) and "Boredom" (bottom) issues take exception to the obsession with youth and titillation in popular culture.

2001 *Above right:* Imposing the faces of American presidents as they appear on dollar bills on a map of the USA, Carrie McLaren's cover of an issue of *Stay Free!* published in 2001 comments on the way that advertising is penetrating into education.

One of the most significant political developments of the 1990s was the rise of anti-consumerist activism. Protest against the cultural effects of globalization and the ecological impact of modern industry and communications spawned a new wave of publications. Unlike protesting groups in the past, which issued meagre, ascetic pamphlets, the editors of many of these new magazines acknowledge the powerful effects of design on consciousness by adopting the high production values of mainstream publishing. The line between political critique and radical chic is a hard one to walk: after all, advertisers – trying to court a young market – are happy to adopt the rhetoric of protest if it will lend fashionable associations and status to the products that they promote.

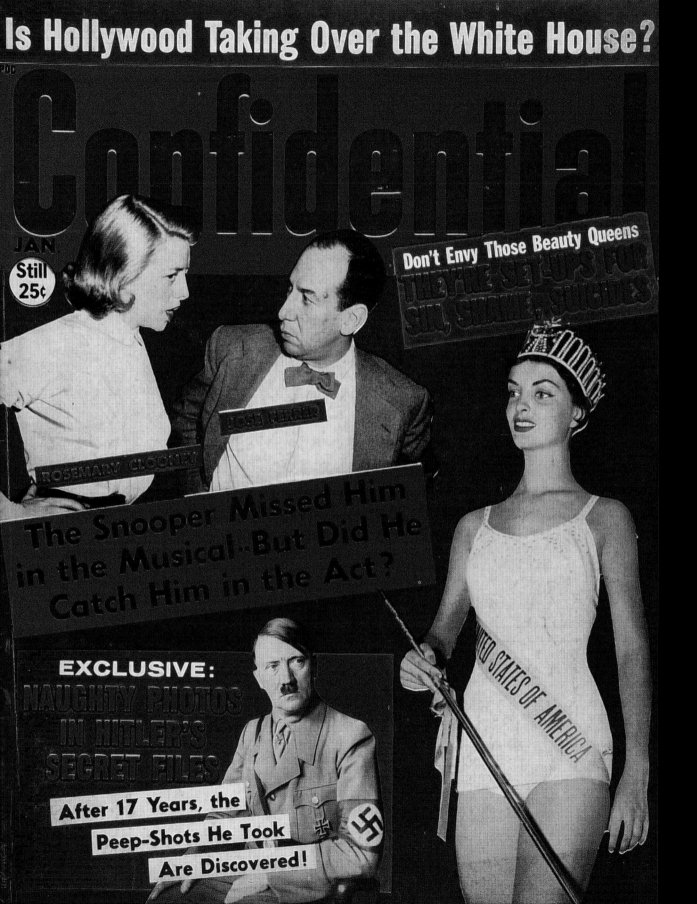

CELEBRITY AND POPULAR CULTURE

The primacy of entertainment ... converts our politics into entertainment, our religion into entertainment, our education into entertainment, and virtually all of our magazines into vehicles of entertainment.

Neal Gabler, author of *Life, the Movie: How Entertainment Conquered Reality*, 1998

A. XX - N. 12 - Milano, 20 Marzo 1958

TEMPO

L'AVVENTUROSO
VIAGGIO DELLA
CASA REALE DA
ROMA A BRINDISI

*

Colloqui con

UMBERTO
DI SAVOIA

di GIOVANNI ARTIERI

Luogotenenza
Regno Esilio:
dramma di due anni

SOFIA LOREN

80 LIRE

CELEBRITY AND POPULAR CULTURE

Magazines play a key role in the promotion of celebrity. While many of the most popular figures in the public eye owe their fame to their efforts in the fields of entertainment, politics, sport, or the arts, their celebrity goes far beyond their professional achievements. Reporting the famous, magazines have long encouraged their readers to believe that they can know their character and see inside their private lives.

In the 19th century, caricatural magazines *Le Charivari* in France and *Punch* in England circulated sketches of members of the ruling elite. The *portrait-chargé* – a depiction that displayed exaggeration and verve – promised to reveal the character of their subjects.

The development of printing processes to reproduce photographs at the end of the 19th century encouraged the development of magazines relating the lifestyles of the famous. Photography's capacity to capture the world matched celebrity's promise to the viewer that they could know and touch the object of their desire. The Hollywood studios in the 1920s and 1930s exploited public appetites by creating carefully staged images of their film stars, on and off stage. Today, image management is an industry serving many fields of public life. Magazine editors – particularly since the rise of a new generation of gossip magazines like *Hello!* and *OK!* in the 1990s – have been resourceful when the images they need are unavailable, often commissioning long-lens paparazzi photographers. The question of the extent to which the lives of the famous should be public has become highly controversial and has seen editors in the dock.

1958 *Opposite:* This beautifully toned and hand-touched portrait of Sophia Loren appeared on the cover of Italian magazine *Tempo*.

1962 *Previous page:* Designed by Leonard Kabatsky, *Confidential* was an American scandal sheet in the tradition of 19th century penny dreadfuls.

1965 *Top right:* A precursor of gossip magazines like *Hello!*, *Tit-bits* departed from its standard pin-up cover shot when it published these photographs of a playful Princess Margaret and Lord Snowdon at the opening of a gallery.

2000 *Right:* Gossip magazines compete to publish images of events in the lives of celebrities. The commercial imperative to beat the competition means that titles like *Hello!* are sometimes prepared to publish grainy or ill-composed images photographed by paparazzi. Snatched photographs of the wedding of Hollywood stars Michael Douglas and Catherine Zeta Jones brought *Hello!* into the dock accused of invasion of privacy in 2003.

1945 *Above:* The atmospheric studio portrait of Joan Bennett, the star of *Scarlet Street,* on the cover of *Movie Story Magazine* hinted at the themes of love and crime in this film.

1948 *Right: Hollywood's Family Album* was based on a format that grew in popularity after 1945. Presenting stars like Betty Grable with their families, the editors of this magazine served the widespread interest in homemaking in America after the return of the troops from the Second World War.

c.1936 *Opposite:* This uncredited portrait of Carole Lombard for the cover of *Screen Guide* was probably shot by Eugene R Richie a few years earlier. Published in a cheap title on poor paper, the photograph still stands out as a provocative and beautiful image that makes the young star look as if she were carved from marble. Lombard was described by writer and collector John Kobal as "emulating the Dietrich languor with eyelids half-closed but eyes, one feels, open with laughter, should anyone take her too seriously."

HOLLYWOOD ON THE COVER

The American movie industry in the 1920s and 1930s walked a fine line between provoking moral outrage and titillation. By 1920 its explosive success – in little more than two decades since film's invention – had unpredictable effects. Movie stars – flushed with money and success – were acquiring scandalous reputations as drug-taking sexual libertines. As movies became more expensive to make and the stars increasingly vital to the success of a film, the Hollywood studios built the "star system" to protect their investments. The studio controlled the public image of its movie stars through efficient and well-connected publicity departments (and even inserted moral clauses into actors' contracts). After the film itself, the most important promotional tool was the photographic portraits that were supplied to the numerous movie magazines of the period. Photographers like Eugene R Richie

achieved the remarkable feat of lending stars like Dietrich and Lombard the aura of both intimacy and mystery. For writers like John Kobal the 1920s and 1930s were the heyday of the Hollywood studio portrait. The rise of photo-journals such as *Life* and *Look* in the 1940s, which promised to capture the human qualities of their subjects, meant that informal portraits became the order of the day. Moreover, post-war morality – reinforced by an updated Hayes Code (The Motion Picture Production Code), introduced in 1930 to control images of nudity, sexuality and violence – meant that the face of the Hollywood star was best captured in a family portrait.

SCREEN GUIDE

NOVEMBER

10
CENTS

PHOTO
PARADE

IN
THIS ISSUE
250
CANDID
PHOTOS

CAROLE LOMBARD

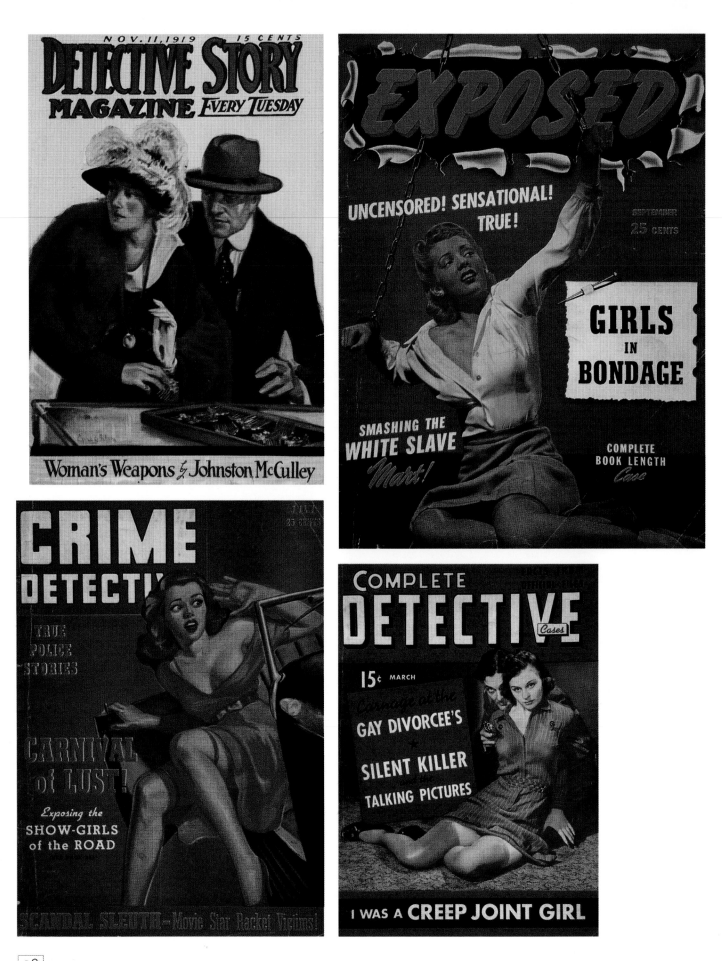

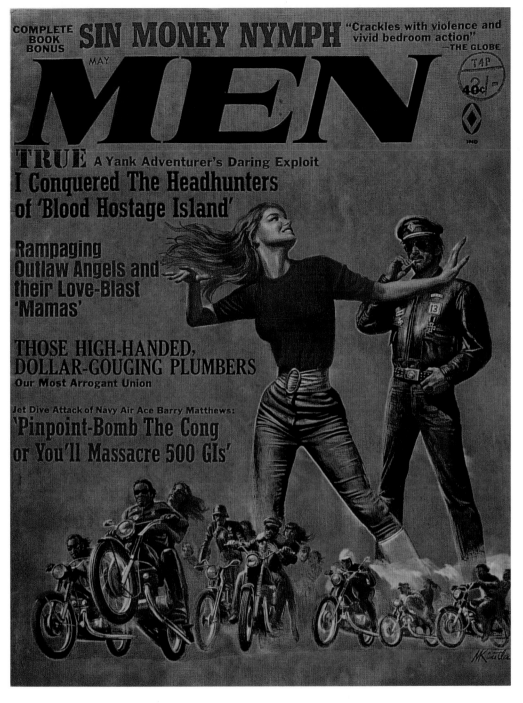

COMPLETE BOOK BONUS **SIN MONEY NYMPH** "Crackles with violence and vivid bedroom action" —THE GLOBE

MAY **MEN** 40c-

TRUE A Yank Adventurer's Daring Exploit

I Conquered The Headhunters of 'Blood Hostage Island'

Rampaging Outlaw Angels and their Love-Blast 'Mamas'

THOSE HIGH-HANDED, DOLLAR-GOUGING PLUMBERS Our Most Arrogant Union

Jet Dive Attack of Navy Air Ace Barry Matthews:

'Pinpoint-Bomb The Cong or You'll Massacre 500 GIs'

CRIME PULPS

Detective Story Magazine – which first appeared in 1915 – is usually credited as being the first crime pulp, and, with its emphasis on expert detectives and gentlemen criminals, it owed much to the writings of Conan Doyle. The genre of the crime pulp really took off in the 1920s – against a backdrop of prohibition and growing gangsterism in America. Combining sexuality and violence, 1940s titles like *Crime Detective* and *Exposed* made their contents clear, albeit within limits. While sadism was tolerated, nudity was not. Roger T Reed puts the success of such titles down to their psychological effects. "The pulps tap directly into our primal nervous system: the fight or flight reflex, the pleasure centre, the gut, the tear ducts – places where violence, power, awe, sex, horror, hero worship, and xenophobia stir our impulses." Many contemporaries viewed their powerful appeal with disdain. In the 1930s New York Mayor LaGuardia called for a code of decency that would curb the representation of sex and violence on the pages of these magazines. The crime pulps declined in the 1950s, quicklyovertaken by the rise of what cultural historian Bill Osgerby has called "macho pulps" like *Men,* as well as the mainstream success of soft pornography.

1953–1973 *Clockwise from top left:* May 1953 edition of the British edition of *The Ring* depicting a Chicago bout between "Jersey" Joe Walcott and Rocky Marciano; January 1962 issue of *Boxing Illustrated Wrestling News*; the crisply retouched and coloured photograph on the cover of this February-March 1973 issue of *The Ring* focuses the viewer's attention on Ron Lyle's striking blow; November 1962 issue of *Boxing Illustrated Wrestling News* with a portrait of an intense and young Cassius Clay (Muhammad Ali). *Opposite:* A pantheon of boxing greats from the 1960s on the cover of the April 1970 issue of *Boxing Illustrated* designed by Mino Busi.

BOXING MAGAZINES

The art of the boxing magazine has changed little in its long history. The image of two muscular fighters squaring up to each other has been standard fare in magazine publishing for more than a century. The 1950s and 1960s were the heyday of American titles like *The Ring* and *Boxing Illustrated*, published in popular international editions. With public interest high in charismatic stars like Sonny Liston and Cassius Clay, and television unable to capture the explosive action of the ring, their photographers and illustrators could depict the drama of the big fight.

Post-war America was policed by the guardians of moral virtue. At this time, the Comic Code Authority sought to prohibit comics which, they said, represented "bloodshed, gruesome crimes and lust", and Hollywood was regulated by the Hayes Code, which had been introduced to protect "public decency". In similar fashion, the editors of boxing magazines promised "entertaining and clean" content. They wanted to make sure that readers did not confuse their publications with pulp titles like *Men* and *Macho* which made sex and violence their staple themes (though the magazines often reported women's wrestling with relish).

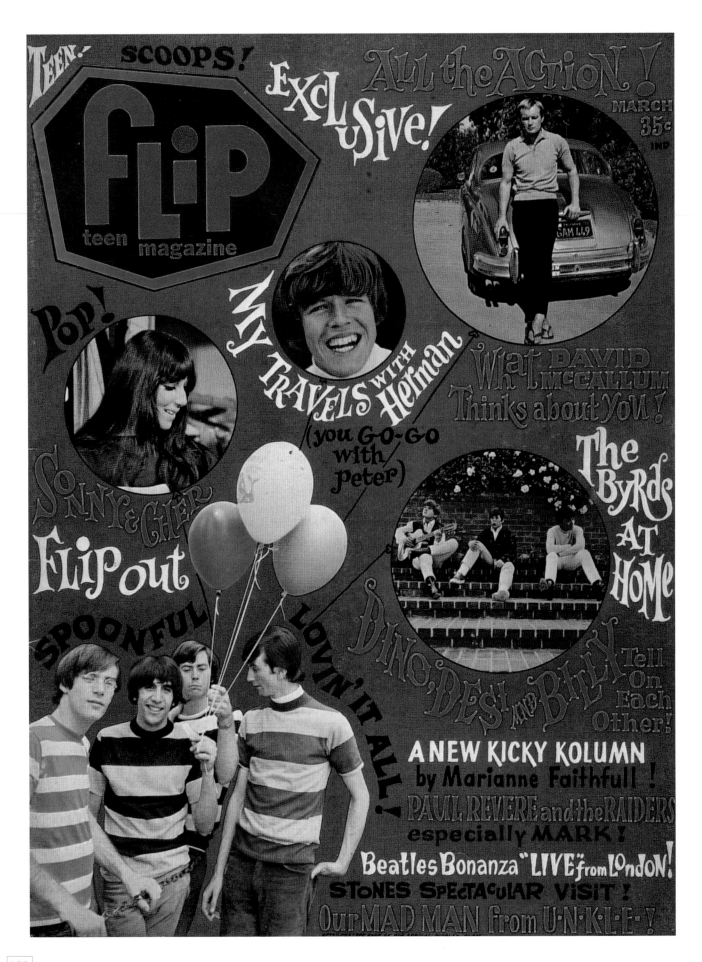

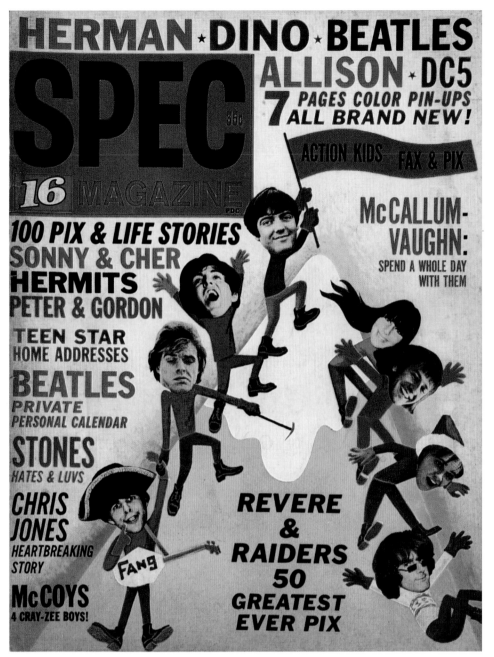

HERMAN ★ DINO ★ BEATLES
ALLISON ★ DC5
7 PAGES COLOR PIN-UPS
ALL BRAND NEW!

SPEC
16 MAGAZINE
PDC
36¢

ACTION KIDS FAX & PIX

100 PIX & LIFE STORIES
SONNY & CHER
HERMITS
PETER & GORDON
TEEN STAR
HOME ADDRESSES
BEATLES
PRIVATE
PERSONAL CALENDAR
STONES
HATES & LUVS
CHRIS
JONES
HEARTBREAKING
STORY
McCOYS
4 CRAY-ZEE BOYS!

FANG

McCALLUM-
VAUGHN:
SPEND A WHOLE DAY
WITH THEM

REVERE
&
RAIDERS
50
GREATEST
EVER PIX

WORLD'S POP STARS IN COLOUR COLOUR COLOUR
Fabulous
WORLD ROUND UP
PLUS KING SIZE COLOUR PIN-UPS OF
WALKER BROS • ELVIS • SEEKERS • WHO • ALAIN DELON • NICK SHRODE
1st PART OF HOLLIES' GIANT PIN-UPS • WIN A TRIP TO PARIS

1966 *Above:* The tremendous success of *Fabulous*, a large format photo-magazine first published in Britain in 1964, was connected to the meteoric rise of the Beatles. *Fabulous's* editors wrote that their magazine "arrived at the birth of another phenomenon which became big, colourful and Today. Merseymania."

1966 *Left:* This special issue of *16 Magazine* sought to beat the dense stack of titles on the news-stand by listing the names of those bands most likely to catch the reader's eye along the top and the left flank of the cover.

1966 *Opposite:* With its busy design, jumpy type and "teen-speak", the March 1966 issue of *Flip* could not be mistaken for anything but a pop magazine.

MAGAZINES FOR TEENAGE READERS

The teenager was an invention of the post-war consumer boom. Colin McInnes, the British novelist, wrote: "We are now in the presence of an entirely new phenomenon in human history: that youth is rich. Earning good wages, and living for little, or even for free, like billeted troops on poor Dad and Mum, the kids have more spending money than any other age group of the population." Market research into the growing purchasing power of the young encouraged magazine publishers on both sides of the Atlantic to create new products. Dozens of new titles appeared on the news-stands offering "signed" pin-ups and insight into the secret lives of pop stars.

At the same time, stars like the Beatles and the Monkees carefully cultivated their images on the album cover, on the magazine page and on screen. Before the sexual revolution of the late 1960s, this meant a careful cultivation of desire without outraging the guardians of good taste. Then, as today, male pop stars were styled as appealing boys rather than as sexually-mature men. The technique employed by *16*, an American title that first appeared in 1957, was to represent the bands and singers on the cover as cartoon characters. Titles like *Fabulous* in Britain and *Flip* in the USA created for their readers a feeling of complete intimacy and rapport with the singers and groups of the time. Distant and glamorous, the teen mag made them available on demand.

1977 *Opposite: Sounds,* a pretender to the *NME*'s crown as king of the music papers, enjoyed a boom in the late 1970s on the back of punk. This cover portrait of Richard Hell in typed letters was produced using a rudimentary computer programme.

1958 *Below:* Although rock'n'roll had arrived on British shores a few years earlier, this pantheon of pop stars testifies to the continued interest in jazz, big bands and American crooners.

1962–1974 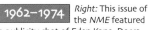 *Right:* This issue of the *NME* featured a publicity shot of Eden Kane, Decca Records' answer to American singers like Frankie Valli. *Below right:* Following the rise of rock music in the late 1960s (with offshoots like Glam Rock), boy-next-door good looks and a winning style were replaced by the inverted glamour of gender-bending and hedonism, as this cover portrait of David Bowie suggests

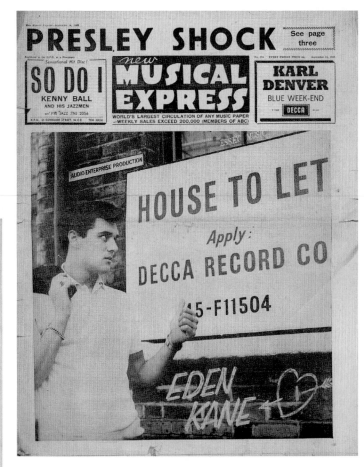

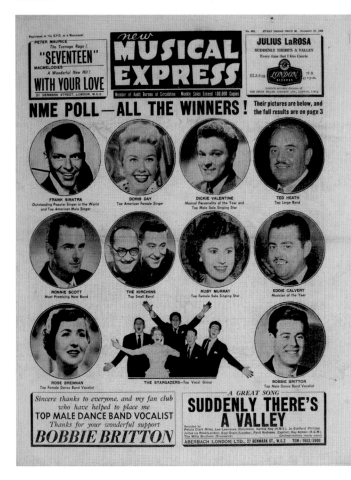

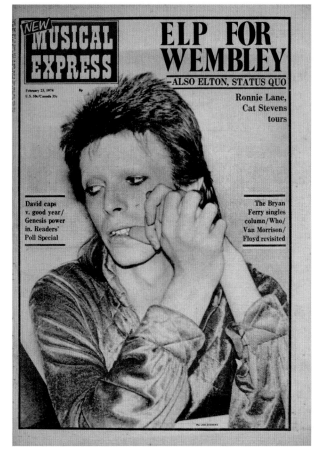

THE MUSIC BROADSHEETS

The roots of the music press in trade publications were still clear in the inky black-and-white newspaper format that prevailed until the 1980s. The *New Musical Express* was founded in 1951 to report new record releases and tour dates. In those days its attitude to rock'n'roll was sometimes condescending, with writers preferring serious music like jazz. However, rock'n'roll's incontestable popularity forced a change in editorial direction. Always walking a line between teen pop magazines and serious-minded journals, titles like *NME* and *Sounds* enjoyed a heyday in the 1970s when rock and punk music vied for popularity.

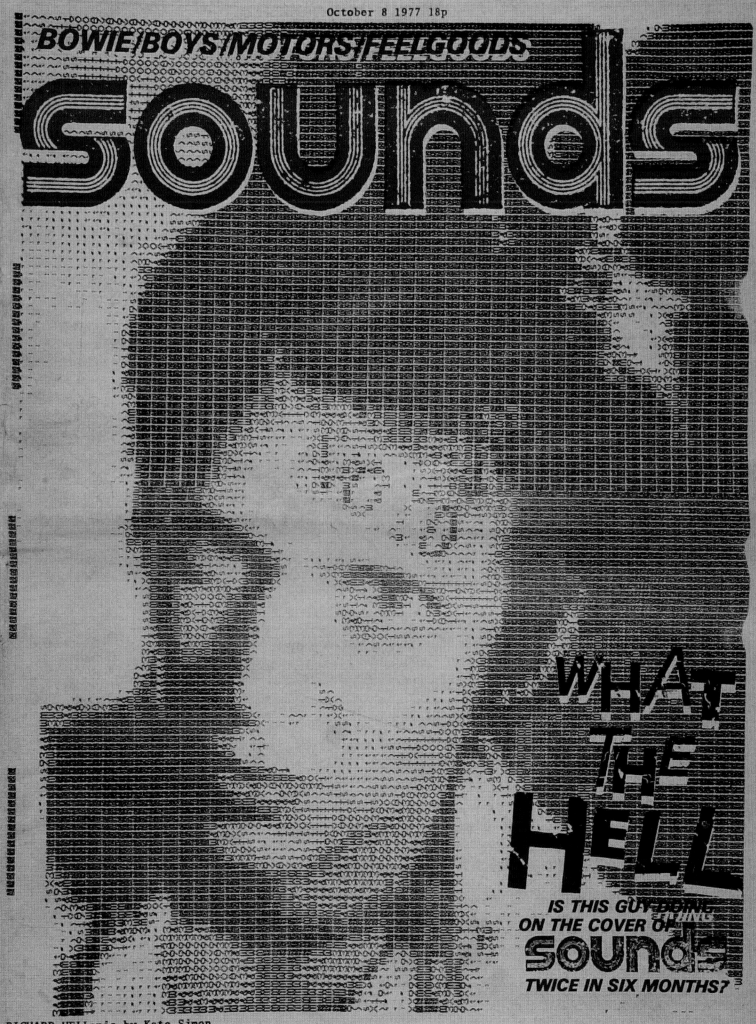

October 8 1977 18p

BOWIE/BOYS/MOTORS/FEELGOODS

SOUNDS

WHAT THE HELL

IS THIS GUY DOING ON THE COVER OF SOUNDS TWICE IN SIX MONTHS?

RICHARD HELL:pic by Kate Simon

 1977 *Right: Ripped & Torn,* 1977. This cover features Johnny Rotten, in an image that echoes Jamie Reid's famous design for a Sex Pistols single.

1977 *Below right: Search and Destroy,* from San Francisco, displayed a more sophisticated approach to design than many of its British counterparts. The parachuting commando on the cover mocked the magazine's self-appointed mission to search out and destroy conceited rock culture in the US.

1977 *Far right: Sniffin' Glue.* Produced by Mark Perry and Danny Baker, this British fanzine became the best known punk title.

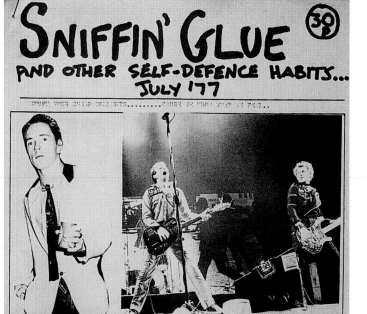

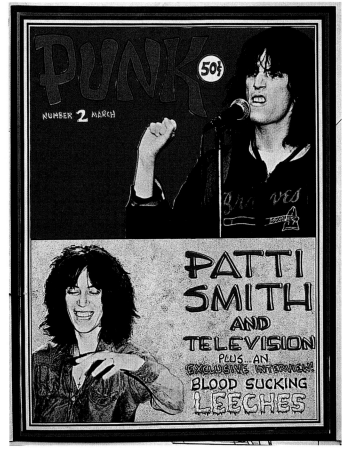

1976 *Far left:* This magazine represented the New York Punk scene that centred on CBGB's, a much-mythologized club in the city. Like *Search and Destroy* from the East Coast, *Punk* was more upmarket than its British counterparts.

1977 *Opposite:* Adopting the graphic style of the fanzines (and employing their writers), *Zigzag,* published by a limited company, represented Punk's move into the mainstream.

PUNK FANZINES

Punk fashion and music emerged in the mid-1970s as a response to the pretensions of progressive rock and glam rock. Enthusiasm and opinions were more important than expensive equipment and slick techniques. Punk fanzines shared these principles. Writers and designers not only produced these cheap, photocopied publications without "professional" skills, but made a virtue of their amateurism. Mastheads, for instance, were made from lettering sliced from glossy magazines or simply hand-written to match the direct, colloquial style of the articles. Punk objected to the consumer society. As the editor of *Sniffin' Glue* put it: "Shout about being exploited by fashion companies, newspapers, magazines ... fight for the right to maintain yer individuality, surprise yourself Punk, hit back, STOP POSING". Yet the movement was well aware of its commercial value. Like the groups that they reported, fanzines broadcast Punk's rage against society, while making it an attractive, bankable commodity.

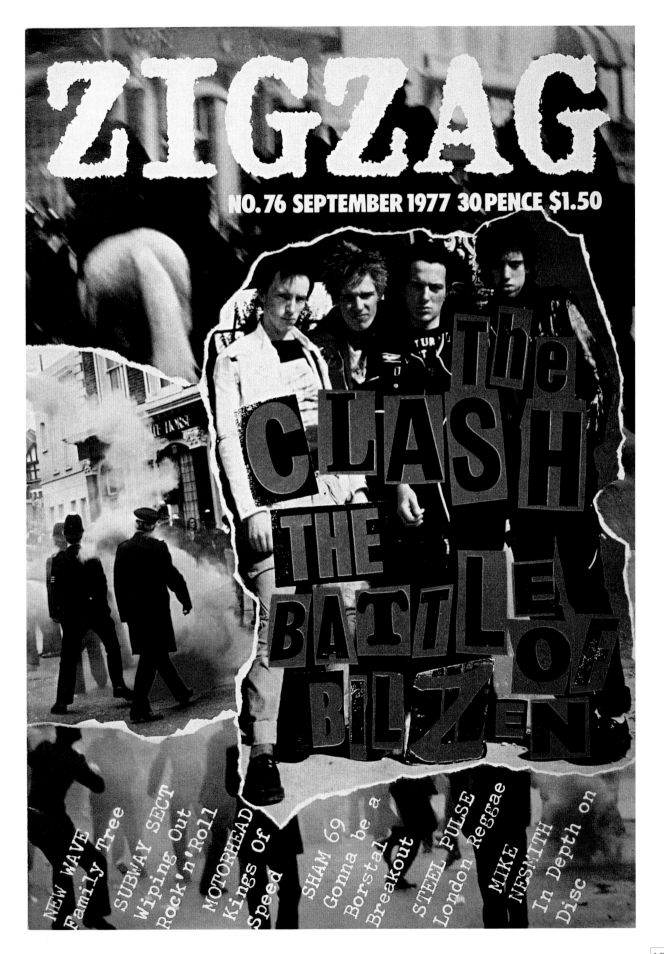

ZIGZAG

NO. 76 SEPTEMBER 1977 30 PENCE $1.50

The CLASH THE BATTLE OF BILZEN

NEW WAVE Family Tree

SUBWAY SECT Wiping Out Rock'n'Roll

MOTORHEAD Kings Of Speed

SHAM 69 Gonna be a Borstal Breakout

STEEL PULSE London Reggae

MIKE NESMITH In Depth on Disc

THE FACE

ITALY L 4500 GERMANY 6 50DM

THE FACE No. 92 DECEMBER 1987 £1.20 ● US $3.75

BOB'S YOUR UNCLE

DE NIRO DELIVERS

■ EXCLUSIVE INTERVIEW

Aretha Franklin, Edwyn Collins, Carrie Fisher, Angela Winbush
Shopping, Bluffer's Guide to Classical Music, 22 pages fashion

photography KEES TABAK/RETNA image manipulation DAVID WOOD

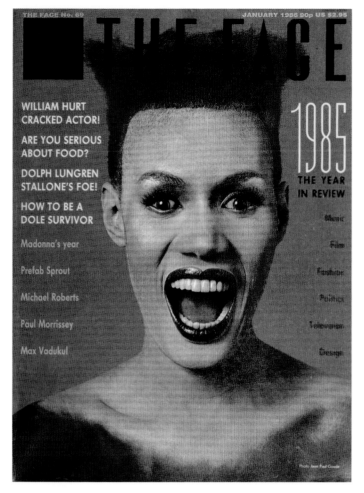

1985–2001 *Opposite:* Kees Tabak's straight portrait of American actor Robert de Niro was manipulated to give the impression of being viewed through a television screen. An illusive figure, reluctant to give interviews, de Niro is famous for living his roles, and this cover captures the difficulty of penetrating his mask. *Above:* Brody framed Jean Paul Goude's portrait of controversial pop singer Grace Jones with a masthead and other text in typefaces that he had designed expressly for the magazine. *Right:* Stripped of coverlines, Toby McFarlan Pond's portrait of the French pop duo Daft Punk is dramatic and enigmatic.

*T*HE FACE, A BRITISH MONTHLY LAUNCHED BY NICK LOGAN, IS THE BEST KNOWN OF A CLUSTER OF PUBLICATIONS THAT APPEARED IN 1980 INCLUDING *I-D* AND *BLITZ*, REPORTING FASHION, FILM AND MUSIC.

Well-versed in the history of street style, *The Face* took its title from the 1960s culture of the Mods. In this world, "Faces" were acknowledged as style-setters in a fast-changing world of fashion. This was, in fact, the role that *The Face* carved out for itself. Its self-appointed assignment was to identify, and even to stimulate, the rapid turns and ascending currents of "style culture".

Even hard times could be viewed through this prism. Unemployment and poverty – pressing social issues in the 1980s – were treated to a journalistic investigation of life in the underworld of "dole survivors" with shadowy black-and-white documentary-style photographs. In the 1980s *The Face* was widely celebrated for its graphic inventiveness. Its principal designer between 1981 and 1986, Neville Brody, was even awarded the accolade of his own exhibition in London's Victoria and Albert Museum in 1988 largely for his work on this magazine. His designs – distinguished by a keen and inventive use of type – are often claimed to have defined

the look of magazines of the period. In fact, Brody designed a number of typefaces and graphic devices like the El Lissitzky-inspired red and black wedges on the masthead expressly for the magazine. Brody's success on *The Face* was also his failure. The magazine's commitment to riding the waves of style meant that Brody's work was inevitably going to date on its pages sooner rather than later. In light of this, while Brody's successors have maintained the magazine's trademark cover headshot, they have also tended to under-design the magazine, avoiding elaborate graphic devices and favouring utilitarian type.

1993–1995 David Carson used type extravagantly on the cover of *Ray Gun*. In the acknowledgement describing the cover artwork, the type designer would often be credited alongside the photographer.

Ray Gun, AN AMERICAN MUSIC MAGAZINE FIRST PUBLISHED IN 1992, ACHIEVED AN UNUSUAL REPUTATION AS A TITLE BOUGHT NOT JUST FOR ITS CONTENT, BUT ALSO FOR ITS DESIGN.

Ray Gun's first 30 issues were designed by David Carson whose irreverent approach to type and magazine layout made him an iconic figure in the world of graphic design. In his designs for *Ray Gun*, he abandoned many magazine cover conventions such as the importance of a fixed masthead. *Ray Gun*'s masthead mutated almost every issue, sometimes appearing like copperplate letters and often verging on illegibility. Reflecting the disdain for celebrity in the rock music culture that the magazine reported, its designer also exploited the aesthetic charge of blurred and over-exposed photographs. *Ray Gun*'s disordered style dated quickly, though Carson remained in high demand as a designer who captured a mood and a moment in American culture.

RAYGUN

on the road
with Sonic
youth

racker

aterboys

ar jawbox

idnight oil

atthew

weet leonard

hen new

der anthr

on jovi? red

rton heat etc

JULY 1993
£2.50
07
5 USA
5 CANADA
JULY

special collectors collectable issue

1985–1992 *Right:* Richard Bernstein's hand-painted portrait of pop singer Annie Lennox offers a larger-than-life impression of the singer. *Opposite left:* Working from Greg Gorman's photograph of actor Mickey Rourke, Bernstein's painting presents a perfected image of celebrity. *Opposite top right:* Fashion photographer Bruce Weber's portrait of young actor Stephen Dorff and Courtney Wagner offers an apparently private moment for public consumption. *Opposite bottom right:* Albert Watson's portrait of movie actress Uma Thurman was used on this immaculate cover, a quality emphasized by the appearance of the word "clear" above the masthead.

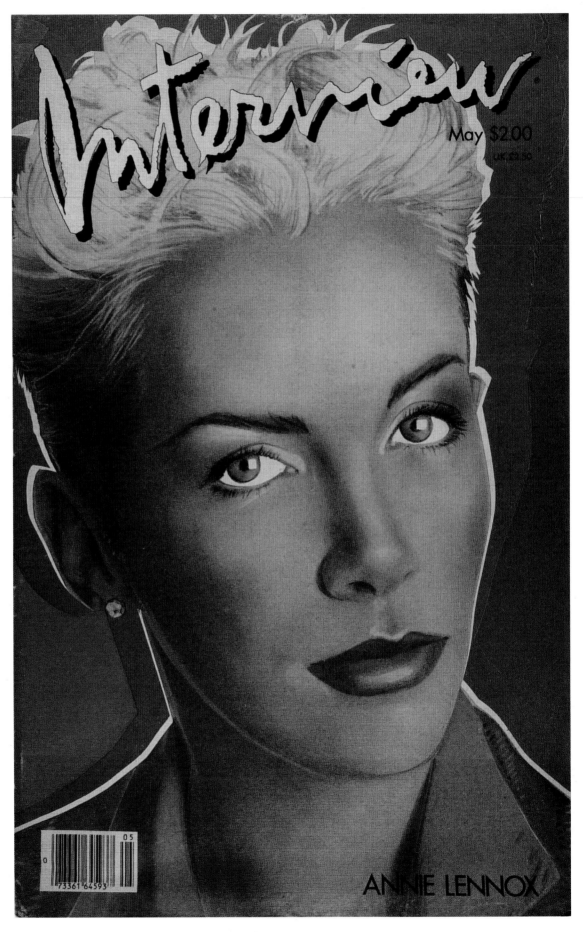

Interview

May $2.00

UK. £2.50

ANNIE LENNOX

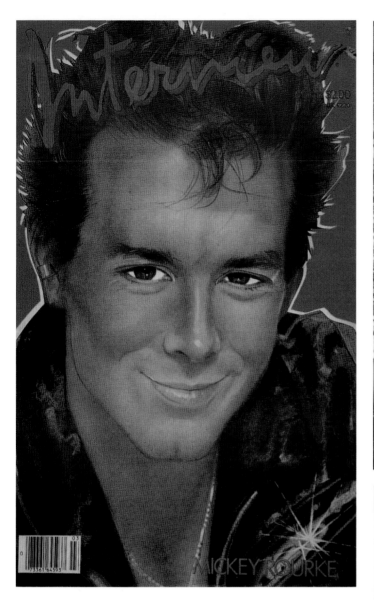

MICKEY ROURKE

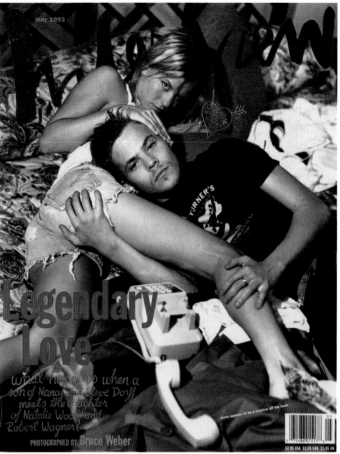

may 1993

Legendary Love

What happens when a son of Nancy and Steve Dorff meets the daughter of Natalie Wood and Robert Wagner?

PHOTOGRAPHED BY Bruce Weber

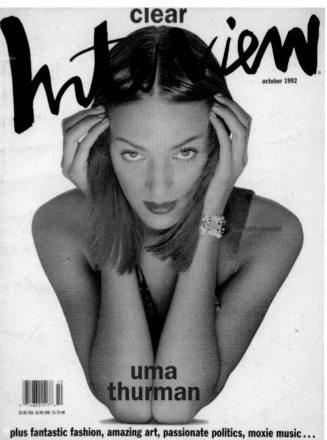

clear

Interview®

october 1992

uma thurman

plus fantastic fashion, amazing art, passionate politics, moxie music...

*I*NTERVIEW WAS LAUNCHED BY ANDY WARHOL IN 1969 AS A FILM JOURNAL. Yet movies receded in significance on its pages as fashion and celebrity became its staple themes, reflecting Warhol's own fascination with mass culture and glamour. *Interview* offered its readers inside knowledge through celebrity interviews (where one famous personality – including Warhol – interviewed another) or by profiling models, make-up artists and designers. Richard Bernstein's cover illustrations from the 1980s made reference to Warhol's monumental screen-printed portraits. The large-format and pastel-toned covers "improved" the publicity photographs on which they were based. When Warhol died in 1987, *Interview* was redesigned by Fabien Baron, a designer who had made a high reputation for his classically inspired work on Italian *Vogue* in the 1980s. Baron retained and revised some elements of the cover such as the masthead, but made stronger use of photography.

Week Ending September 11 1948 THE NATIONAL HOME WEEKLY Every Thursday Fourpence

Woman

Wonderful three-in-one Woman Pattern

1
THIS ROMANY BLOUSE

2
EMBROIDERY TRANSFER

3
CRISP SHIRT-BLOUSE

see page eight

Do I worry 'cause you're
stepping out?
Do I worry 'cause you
got me in doubt?
Though your kisses aren't
right, do I give a bag of beans?
Do I stay home every night
and read my magazine?

"Do I Worry?" Ink Spots song lyric, early 1940s

JULIET WILBOR TOMPKINS · KATHLEEN NORRIS · EDITH WHARTON · VERA L CONNOLLY
AND MANY SPECIAL FEATURES FOR CHILDREN AND PARENTS

Popular magazines have been attacked by many of the commentators who have investigated their appeal. They have been accused of perpetuating stereotypical views of what it is to be a man or a woman and of being "agents of oppression dressed up as popular pleasures". Even the earliest British women's periodicals of the mid-19th century – an age that appeared to subscribe to the "separation of the spheres" – were subject to criticism by those who found them too attached to domestic topics, fashion and serialized fiction. One hundred years later Betty Friedan's sharp criticism of American women's magazines struck a similar note: the regular diet of beauty, fashion and home-related features in titles like *Ladies' Home Journal* narrowed, she argued, the horizons of their readers. Editors of popular fashion and lifestyle titles have tended to reject such criticisms by claiming to provide simply what their readers demand. The question of the knowledge and pleasures that lifestyle titles offer – whether in the form of glossy advertisements or glimpses into the world of high fashion – is, after all, central to their success.

Magazines should not be confused with the lifestyles that they project. In the late 1980s, for instance, there was much

1948 *Previous page: Woman* was the best-selling title in Britain in the mid-20th century. Although conventional in its use of a headshot, this cover displayed more fantasy than usual in the form of the smoky silhouette of a guitarist serenading the model. Inside, the magazine contained practical instructions about how to make her "Romany Blouse".

1929 *Above:* A popular US women's magazine, *Delineator* gave itself an up-market image with its cover portraits of fashionable mannequins. Helen Dryden, the illustrator of this striking Art Deco cover, had made her name working for *Vogue* in the 1910s.

1936 *Right:* Health and beauty have long been staple features of the magazine. The covers of *Physical Culture* reflected popular fascination with the body beautiful – both inside and out – in the 1930s.

1996 *Opposite top left: Eat Soup,* a short-lived British title, was an off-shoot of *Loaded.* Injecting its subject matter – food, drink and travel – with bold sexuality, it sought to appeal to the bacchanalian instincts of its young male readers.

1971 *Opposite top right:* Under the art direction of Arthur Paul, *Playboy's* covers were remarkably coy, sometimes presenting thoughtful meditations on desire.

1957 *Opposite far right: Men Only,* a pocket-size magazine, was first published during the Second World War and was largely aimed at the troops. 'Sherriffs' brilliantly drawn caricature is of popular American actor Danny Kaye.

discussion in the British press about the rise of the "new man", a figure who embodied a new kind of emotionally sensitive masculinity, and the "new lad" whose appetite for traditional male interests was shaded by ironic attitudes to life. These stereotypical categories of masculinity existed largely in the imaginations of advertisers and magazine publishers who wanted to find new ways to persuade men to buy their products. With the exception of specialist hobby titles and mass-market pornography, male readers had been poorly served by the publishing industry. In the late 1980s and early 1990s a range of new titles that approached their readers as "new men", (*Arena*) or as "new lads", (*Loaded*) appeared, often outstripping the women's magazines in terms of sales. Men's reading habits appeared to have changed almost overnight.

This seemed to be a dramatic departure, but the new titles of the 1990s simply revived what had been a mainstay of mid-century publishing. Before becoming openly pornographic magazines like *Men Only* in Britain and *Playboy* in the USA in the 1950s addressed their readers as sophisticated and worldly men interested in literary matters, current affairs, travel and consumerism, as well as sex. The designers and art directors of these "lifestyle" titles (before the term became a buzzword of market researchers and advertisers) enjoyed greater creative freedom than their counterparts today, who are required to dress their titles with portraits of bikini-clad models or in-vogue celebrities. The covers of *Twen* in Germany, *Esquire* in the USA and *Town* in Britain have acquired a kind of mythic status as the epitome of classic magazine cover design.

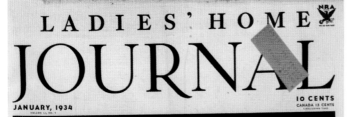

LADIES' HOME JOURNAL

JANUARY, 1934 VOLUME LI, NO.1

10 CENTS
CANADA 13 CENTS
(INCLUDING TAX)

BEGINNING THE CROOKED LANE

BY FRANCES NOYES HART

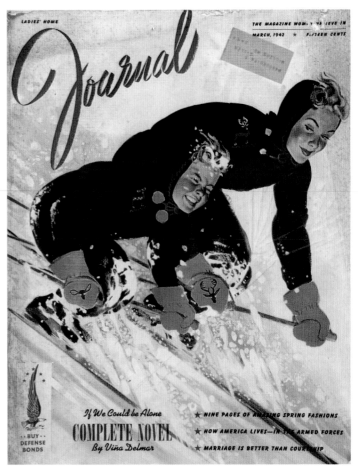

LADIES' HOME

THE MAGAZINE WOMEN BELIEVE IN

MARCH, 1942 ★ FIFTEEN CENTS

Journal

BUY DEFENSE BONDS

If We Could be Alone
COMPLETE NOVEL
By Viña Delmar

★ NINE PAGES OF AMAZING SPRING FASHIONS
★ HOW AMERICA LIVES—IN THE ARMED FORCES
★ MARRIAGE IS BETTER THAN COURTSHIP

1896–1960 *Above:* The January 1934 issue employed this striking portrait by Roy Spreter for its cover. *Top right:* This racy cover of the March 1942 issue included a modernized masthead. Al Parker's illustration offered a dynamic image of America's mothers. *Right:* The cover of the March 1896 issue made a clear reference to the issue of women's suffrage in the figure of an uncorseted and barefoot figure releasing housemartins from their cage. *Opposite:* The 1960 presidential election was represented as a flower arranging competition between the two aspiring first ladies, Patricia Nixon and Jacqueline Kennedy.

TEN CENTS
THE LADIES HOME JOURNAL
MARCH 1896

THE CURTIS PUBLISHING COMPANY, PHILADELPHIA

LADIES' HOME JOURNAL HAS BEEN ONE OF THE MOST SUCCESSFUL AND LONGEST-LIVED WOMEN'S MAGAZINES IN AMERICA. It emerged in 1883 from a column in *The Tribune* and *The Farmer* and within six years it was the best-selling magazine in America. While its second and most famous editor, Edward Bok, was not a campaigning feminist, he encouraged discussion of women's suffrage on the pages, as well as reflection on social reforms like co-operative housing and improved local government. His belief that women should be in control of their lives – whether in terms of their finances or their education – was later inscribed in the magazine's slogan "Never Under-Estimate the Power of a Woman". When, after the First World War, some women were able to combine careers and motherhood, the *Ladies' Home Journal* was "in step" with the social aspirations of its readers. However, for some commentators after the Second World War, the magazine (and others like it) represented a narrowing of horizons. For Betty Friedan, the author of the landmark study, *The Feminine Mystique* (1963), such publications broadcast "the housewife ideal" as the only option available to women. The home became the frame through which all events were interpreted – even presidential elections.

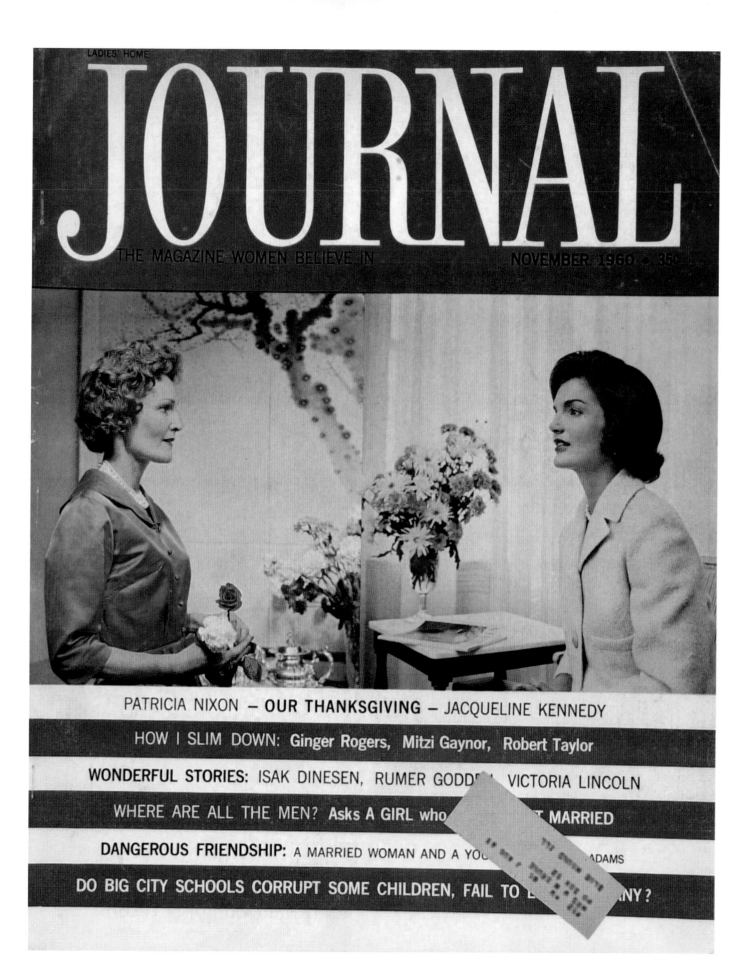

LADIES' HOME

JOURNAL

THE MAGAZINE WOMEN BELIEVE IN NOVEMBER 1960 • 35¢

PATRICIA NIXON — **OUR THANKSGIVING** — JACQUELINE KENNEDY

HOW I SLIM DOWN: **Ginger Rogers, Mitzi Gaynor, Robert Taylor**

WONDERFUL STORIES: ISAK DINESEN, RUMER GODDEN, VICTORIA LINCOLN

WHERE ARE ALL THE MEN? **Asks A GIRL** who MARRIED

DANGEROUS FRIENDSHIP: A MARRIED WOMAN AND A YO ADAMS

DO BIG CITY SCHOOLS CORRUPT SOME CHILDREN, FAIL TO NY?

VOGUE

EARLY PARIS FASHIONS
including Bridal Modes

MARCH·7·1934 (5)
ONE SHILLING

THE CONDÉ NAST PUBLICATIONS LTD.

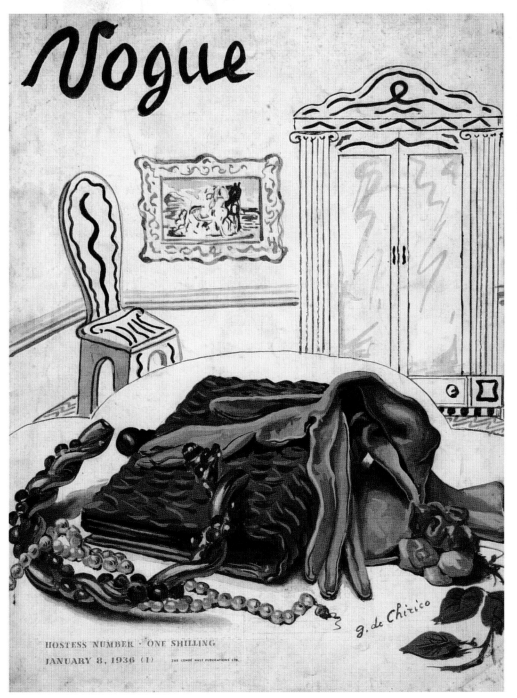

HOSTESS NUMBER · ONE SHILLING
JANUARY 8, 1936 (I) THE CONDÉ NAST PUBLICATIONS LTD.

g. de Chirico

1934 *Opposite:* The full colour photograph on the cover of a 1934 British issue of *Vogue* was taken by American photographer Edward Steichen. Suggesting not just fashionable dress, but a fashionable lifestyle, the model clasps a menu in her gloved-hand.

1936 *Left:* The cover of British *Vogue* was illustrated with a painting by surrealist artist Georgio de Chirico. Later that year London hosted the first surrealist exhibition, a *succès de scandale*.

1933 *Below:* The watercolour on the cover on this issue of French *Vogue* by Eric (Carl Erickson) corresponds with the gestural and expressive style of painting associated with modern Parisian artists like Raoul Dufy and Henri Matisse.

ALTHOUGH *VOGUE* – AND ITS PUBLISHER AFTER 1909, CONDÉ NAST – ENJOYED PERIODS OF ECONOMIC GROWTH AND ENDURED RECESSION LIKE ANY LONG-LIVED PRODUCT, its cultural impact has been a remarkable story of growth from a single title, first published in New York in 1892, to become an early global brand. "National" issues have been produced in France, Britain, Germany, Italy and Russia. Although today these titles have editorial autonomy, for many years they relied on the magazine's French connection to be up to date with the latest fashions in Paris, the widely acknowledged centre of world fashion. In the 1930s Vogue's readers were encouraged to feel part of an international set in intimate reports of high-society life in London, New York and Paris. The magazine's elite tone and cultural aspirations were also displayed in its patronage of modern artists, avant-garde writers and innovative photographers. Unlike post-war titles with international editions that followed a standard template, *Vogue's* covers on both sides of the Atlantic were fluid. The often hand-rendered masthead and the bold use of paintings and colour photographs emphasized the artistic pretensions of the magazine.

1940–1950 *Opposite:* November 1944 edition of *Harper's Bazaar* with cover photograph by Louise Dahl-Wolfe. *Top left:* June 1950 issue of *Harper's Bazaar* with cover photograph by Louise Dahl-Wolfe. *Top right:* June 1950 edition of *Harper's Bazaar* with cover photograph by Richard Avedon. Alexey Brodovitch described Avedon's images as a "vacation from life", appealing because they offered excitement and glamour to America after the strain of war. *Right:* September 1940 cover of *Harper's Bazaar* with a fashion photograph shot on the terrace of New York's Museum of Modern Art by Louise Dahl-Wolfe.

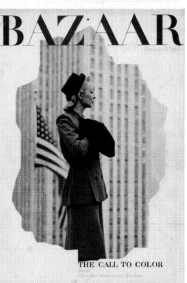

HARPER'S BAZAAR

Harper's Bazaar – first published as *Harper's Bazar* in 1867 – is one of the longest-running titles in American magazine publishing. Its heyday – in terms of photography and design – coincides with the art direction of Alexey Brodovitch who was invited to work for the magazine in 1934. Publisher Condé Nast believed that Brodovitch's experience as a department store and theatre designer in Paris and his knowledge of modern art and design would help stave off the threat posed by the economic crisis of the Depression. He was to be responsible for the design and layout of the magazine up until 1958. Brodovitch has been widely credited for bringing a particular European sensibility to the American magazine by commissioning illustrators such as the French poster-designer Cassandre in the 1930s, however his most important achievements were in the field of photography. In the early 1940s he encouraged young photographers like Richard Avedon and Louise Dahl-Wolfe to abandon the stiff "mannequin" poses that dominated fashion publishing at that time. Brodovitch would then crop and compose their images to startling effect. Looking at the full-colour cover images, usually accompanied by laconic captions, the reader was to be left in no doubt that they were being offered an intensely visual experience.

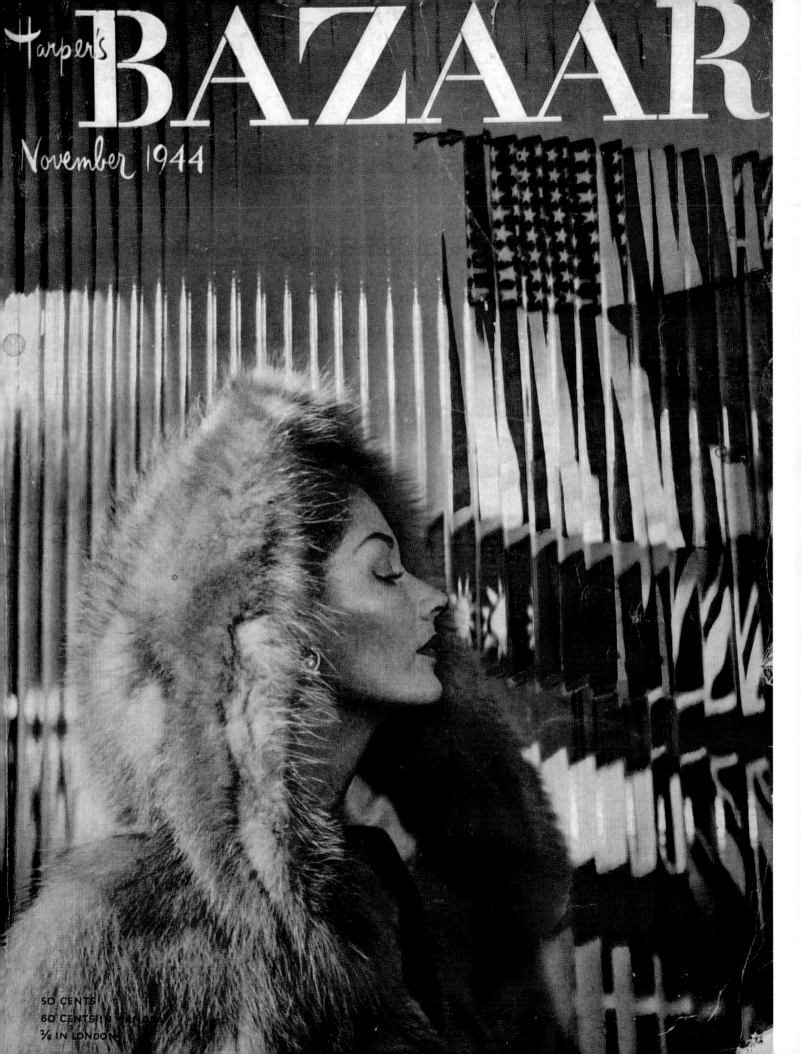

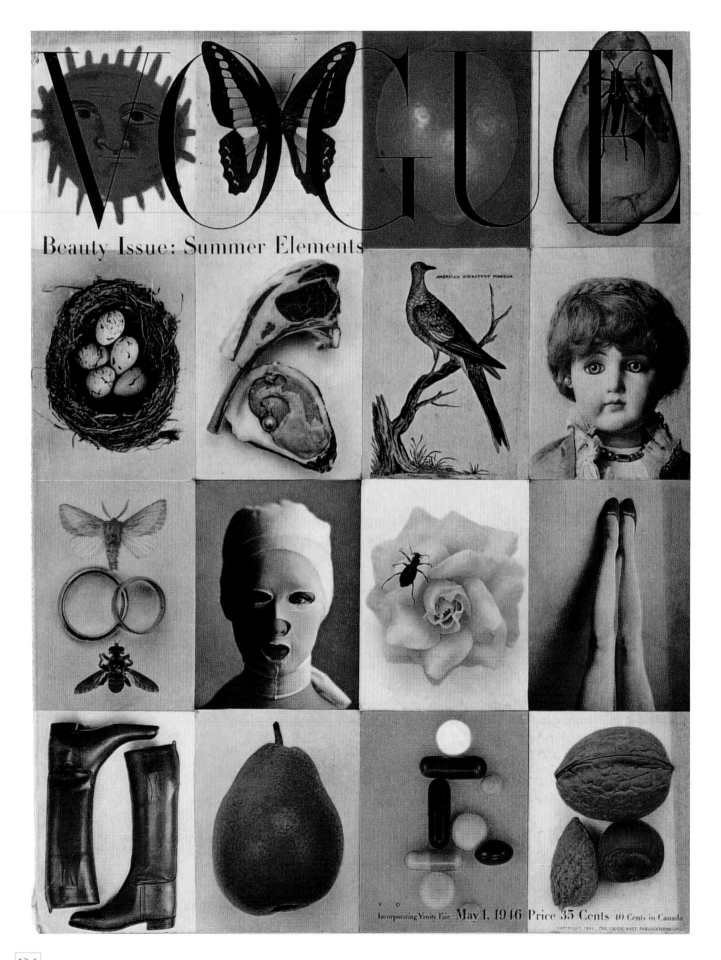

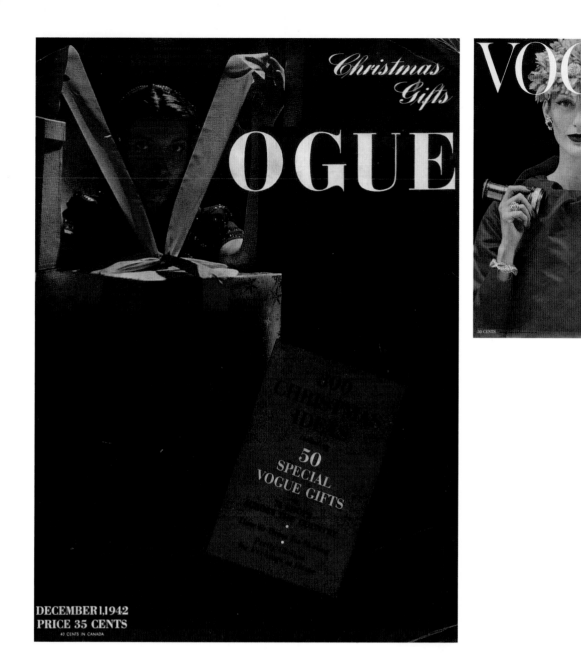

ALEXANDER LIBERMAN AND AMERICAN VOGUE

Russian emigré Alexander Liberman began his career in Paris in the 1920s. In 1933, at the precocious age of 21, he was made art director on *Vu*, the most influential French photo-journal (see page 63). Like many graphic designers and photographers who became influential figures in mid-century America, Liberman fled Europe in the late 1930s to escape the War. He found employment as Mehemed Fehmy Agha's assistant on Condé Nast's *Vogue*, taking over his role as art director in 1942. Although he was sacked by Agha, the support of Condé Nast (an autocratic publisher) ensured that his career stayed on track. By the 1960s he was responsible for almost all of the publishing house's American publications, making him the most important figure in American magazine design.

1942–1955 *Opposite:* Alexander Liberman's cover for American *Vogue* May 1946 took summer as its theme. A brilliantly original cover by the standards of its day *and* the present, it deployed classic surrealist motifs such as the china doll's head and natural history specimens within the typological format of the grid.

Above right: December 1955 issue of American *Vogue* under the art direction of Alexander Liberman and featuring a fashion photograph by Rutledge on the cover. *Above:* December 1942 issue of American *Vogue*. American photographer John Rawlings was commissioned by art director Mehemed Fehmy Agha to compose this cover image.

Liberman's experience as the art director of *Vu*, a photo-journal reporting current events, made him disdainful of what he called the "feminine, condescending approach to women by women's magazines". Under his direction, *Vogue* shed some embellishments like fancy typefaces and enhanced its reputation as an elegant and striking product.

Opposite: The May 1949 issue of *Seventeen* featuring seventeen high-school girls on the cover was photographed by Arnold Newman. *Above:* The beautifully soft-focus photograph of a couple walking in the rain for the cover of the April 1948 issue of *Seventeen* was taken by Francesco Scavullo. *Above right:* To illustrate the fact that the readers had supplied all the copy for the "It's All Yours" issue of *Seventeen* (May 1950), Ray Solowinski's comical photo-montage connected readers and contributors as one.

S EVENTEEN WOULD PROBABLY HAVE BEEN FORGOTTEN AS A MINOR POST-WAR TEENAGE MAGAZINE WERE IT NOT FOR CIPE PINELES' DESIGN.

A graduate of Mehemed Fehmy Agha's studio at *Vanity Fair* and *Vogue*, Pineles – as art director of *Seventeen* after the Second World War – shared Agha's enthusiasm for cropping photographs to dramatize their effect, and for simple, unfussy type. While the content of *Seventeen* often reflected a now lost realm of innocent love and buttoned-up sexuality, (reflected in the gushy slogan "All Yours") Pineles' design and art direction suggested a more sophisticated world just over the teenage horizon. Historian Martha Scotford has described how Pineles moved *Seventeen* away from the school of sentimental illustration to use the best contemporary artists working in America. They included the illustrator Ben Shahn, Robert Gwathmey and a young Seymour Chwast. Pineles herself believed that "an exciting magazine comes with tackling issues that are usually reserved for the printed word and using this material in greater visual depth". Pineles' achievements also lay in the measure of her success in a male world. Despite the high profile of her work, however, her entry into professional bodies like the New York Art Directors Club met resistance.

Nr. 8 1963 5. Jahr 2,– DM 1 H 6773 E

twen

**VIA VENETO:
LIEBE, LASTER, LITERATEN**

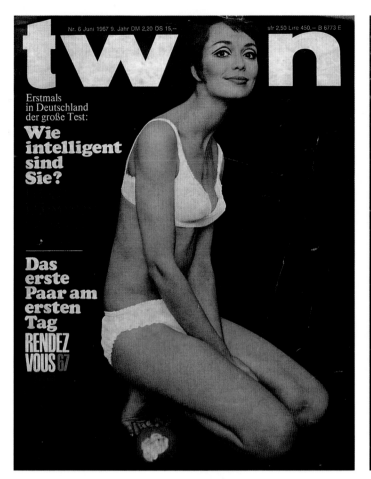

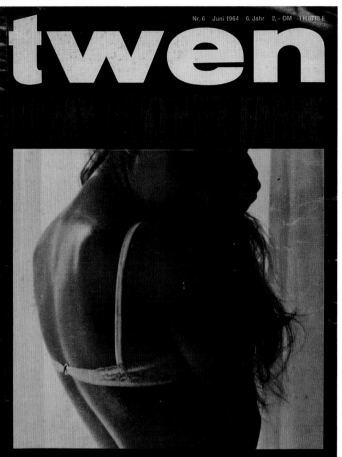

1963–1967 *Above left:* The June 1967 issue of *Twen* offered an image of a modern Eve. *Above right:* This seemingly informal photograph of German actress Romy Schneider was taken by Will McBride. *Opposite:* August 1963 issue of *Twen,* featuring a portrait of Italian actress Claudia Cardinale photographed by Franco Pinna.

*T*WEN – LIKE A CLUTCH OF PUBLICATIONS ON BOTH SIDES OF THE ATLANTIC THAT RANG THE SOCIAL AND CULTURAL CHANGES OF THE 1960S – IS OFTEN DESCRIBED AS A "LEGENDARY" MAGAZINE. From its first appearance on German news-stands in 1959, it reported the *wirtschaftswunder* – the transformation from grey post-war gloom to consumer boom. *Twen*'s readers were attracted to the mix of travel, fashion, sport, and sex, that made up the image of the affluent and liberal way of life that it promoted. Like the art directors working on the great German weekly illustrated magazines of the 1920s, Willy Fleckhaus's reputation lay in

his great ability to compose photographs on the page. Images would be cropped and composed to intensify their emotional and intimate effect. In one now-famous issue, Fleckhaus printed every image in the magazine "life-size", including a close-up of a mixed-race couple kissing on the cover. Although a German-language publication, *Twen* had many admirers abroad who were drawn to its combination of bold graphic design and artful cover pin-ups. New York art director Steven Heller has recalled the powerful impression it made on the "aficionados" who sought it out in the early 1960s. It seemed that European magazines offered a more sophisticated

take on sex than American "cheesecake" publications. *Twen* folded in 1970 as a consequence of internal conflicts and changing cultural politics. Frank Horvat, a great photographer often commissioned by Fleckhaus, has suggested that *Twen*'s sophistication was rocked by the cultural politics of the late 1960s when freedom was increasingly associated with explicit sexuality.

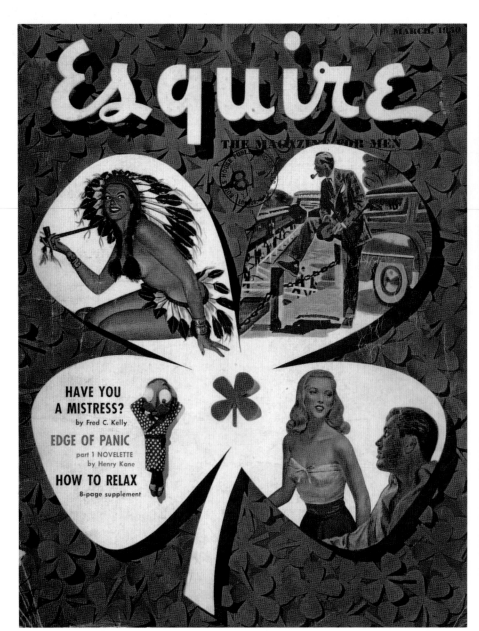

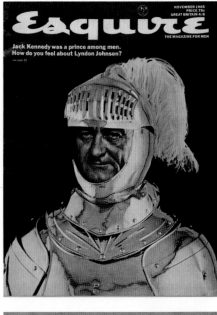

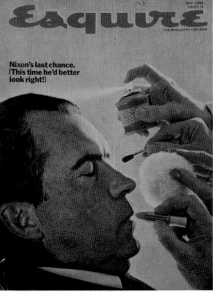

ESQUIRE FIRST APPEARED AT WHAT MIGHT SEEM AN INAUSPICIOUS MOMENT FOR AN AMERICAN MEN'S QUARTERLY ESPOUSING THE GOOD LIFE.

It was launched at the height of the Depression in 1933, yet its up-market style, consumerist ethos and glossy appearance was a rapid success. Ironically, it reached a low point in the 1950s, a time of consumer boom in America. In that period it seemed to lose direction, but a change of staff and editorial in 1957 revived the title. New editor Harold Hayes promised a magazine that would deliver "humor, irreverence, fashion, fine writing, controversy, topicality and surprise". These qualities were delivered in great measure not just by writers like Norman Mailer and photographers like Diane Arbus, but also by George Lois's covers. Combining a brilliant visual imagination with intolerance of arrogance and injustice, Lois was, in Hayes's words, "impossible to regulate or control". Many of his striking covers were the result of elaborate studio shots by photographer Carl Fischer. The Muhammad Ali cover is a case in point. Attacked for his opposition to the Vietnam war and his refusal to fight, Ali was cast as a martyr in the manner of Castagno's 15th century painting of Saint Sebastian. Some Lois covers provoked the

1950–1968 Esquire's predictable 1950s formula of sex and style (top left) was replaced in the following decade by George Lois's striking commentaries on American culture and politics (above and opposite). His combative approach is illustrated by this description of his portrait of John F Kennedy's successor at the White House, Lyndon B Johnson, a figure Lois felt ill-equipped for the office: "stuffing Lyndon's sour puss inside a gleaming Sir Lancelot get up made him look as foolish as I'd hoped".

wrath of his subjects. Richard Nixon's advisers protested against the image of lipstick being applied to the presidential candidate's lips.

The Passion of Muhammad Ali

man about town

CLOTHES • SPORT • TRAVEL • DRINK

WIN A SAVILE ROW SUIT

AUTUMN 58 *three shillings and sixpence*

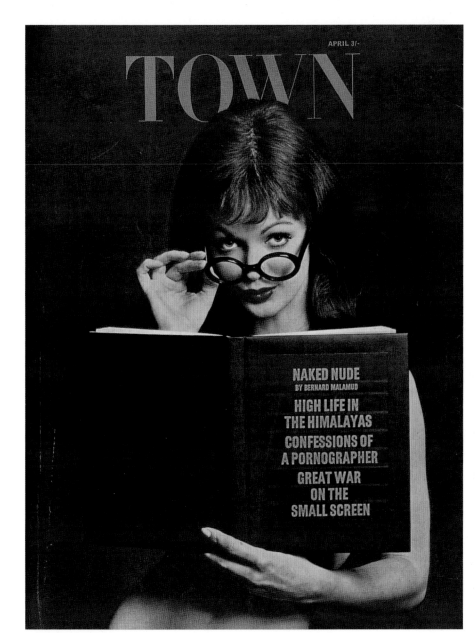

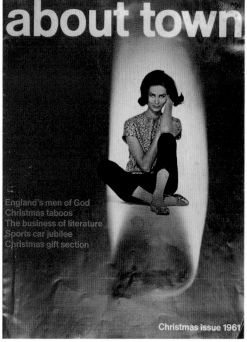

1958 *Opposite:* Almost hidden in the top left-hand corner of the cover of the Autumn issue of Man About Town is a rakish, moustachioed figure of the eponymous subject of the magazine. As the magazine announced on its contents page, "Man About Town helps you to be good at being bad."

Christmas issue 1961

WHILST MOST MAGAZINES TRY TO PROTECT THEIR IDENTITIES AND CHANGE TITLE ONLY UNDER PRESSURE, *MAN ABOUT TOWN* WENT THROUGH THREE TITLES IN AS MANY YEARS.

The original *Man About Town* was a tired tailors' fashion magazine when it was taken over by Cornmarket Publishing in 1959. It was relaunched in 1960 as *About Town,* a title that reflected the magazine's new metropolitan interests in culture and politics. The magazine's new-found editorial sophistication was matched by the powerfully modern design of art director Tom Wolsey, who is credited with combining the design sophistication of Continental modernism with the verve of "American expressionism". Not only a skilled designer, Wolsey was also an excellent judge of talent commissioning then-unknown photographers at the beginning of bright careers, including Terence Donovan, Brian Duffy and Don McCullin. David Hillman of *Nova* recalled how Wolsey told fashion photographers "to go off to an iron works somewhere, and photograph guys wearing immaculate suits halfway up a gasometer". That was considered really bizarre – but as a man, you didn't mind being seen reading it because it was kind of tough and ballsy."

1964 *Above left:* The strong suggestion of nudity in Brian Duffy's cover photograph for the April issue of *Town* illustrates the magazine's growing boldness in matters of sex in the changing cultural climate of the 1960s.

1961 *Above right:* The cover girl was a regular feature of *About Town* (in this instance photographed by John Donaldson). Her steady gaze and coquettish pose make the nature of her interest in the reader plain.

1981 *Right:* The cover model on this early issue of *i-D* was Diana Spencer, future wife of Prince Charles. Reversing the letters of the name given to her in the popular press, Di became *i-D* (as well as an instruction to "Do It Yourself", a central part of the magazine's ethos).

1999 *Opposite:* The masthead's succinct suggestion of a winking eye is echoed in Craig McDean's beautifully polished cover shot of model Guinevere, who also winks at the camera.

1985 *Below:* With its apparently random overlays of vivid colour and distorted type, the cover of "The Art Issue" of *i-D* reflected the creative chaos that art director Terry Jones valued. He described this period in the magazine's history as when "we perfected the art of illegibility".

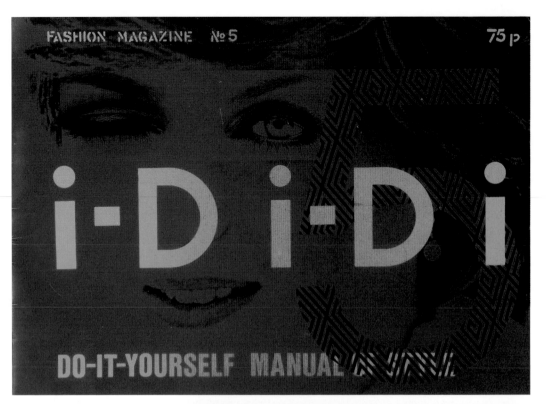

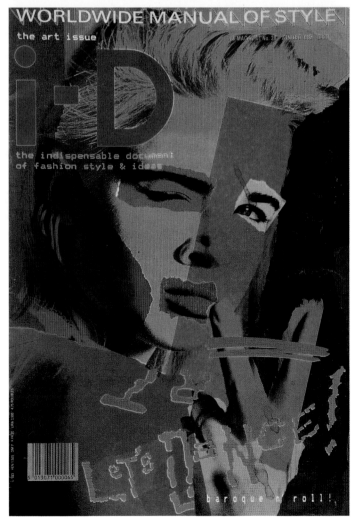

i-D HAS BEEN ONE OF THE LONGEST SURVIVING STYLE MAGAZINES IN BRITAIN. IN ITS EARLY INCARNATIONS, *i-D* REVEALED TRACES OF THE PUNK SENSIBILITY (see pages 106–7 on fanzines). Describing itself as a "Do It Yourself Manual of Style", its photographers and journalists took to the streets of London and other British cities to record "street style", fashionable dress worn with no heed to the prophecies of fashion forecasters and closely connected to styles of music. Curiously, the magazine itself did not emerge from the streets. It was founded in 1980 by Terry Jones, formerly art director at British *Vogue*, who found that his colleagues on this high-fashion title did not share his enthusiasm for the rapid turns of sub-cultural style that followed in the wake of Punk. Dylan Jones, now editor of GQ, and a writer for *i-D* in mid-1980s, described it as "the first magazine to hold a mirror to what it saw, exploiting the boom in youth culture and London's burgeoning reputation as a crucible of young talent". Playing on the title's acronymic name, Jones described *i-D*'s appearance as "instant design". In fact its design often belied reality. The apparently disordered design of many of the covers produced in the 1980s – combining video-grabs and early computer-generated type – was carefully orchestrated by Jones and his colleagues. Despite the vertiginous changes of fashion that the magazine surveys on its pages, *i-D*'s covers have remained remarkably constant since its first issue, continuing to wink at the reader.

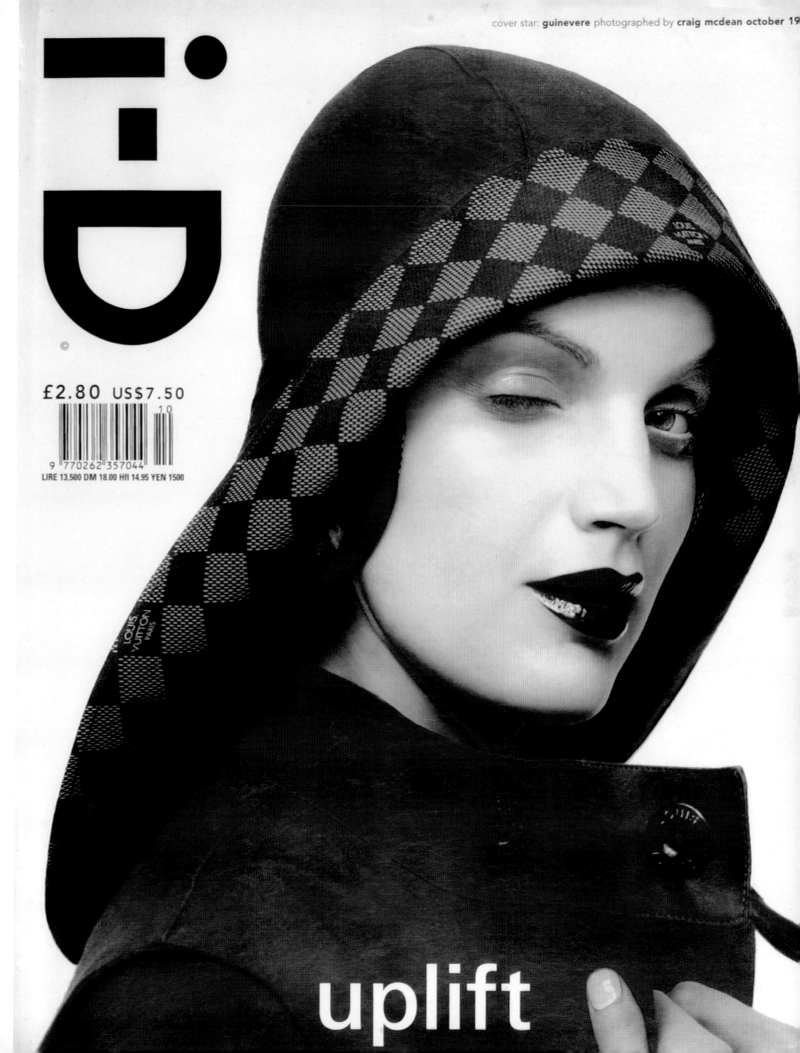

i-D

©

£2.80 US$7.50

10

9 770262 357044

LIRE 13,500 DM 18.00 Hfl 14.95 YEN 1500

uplift

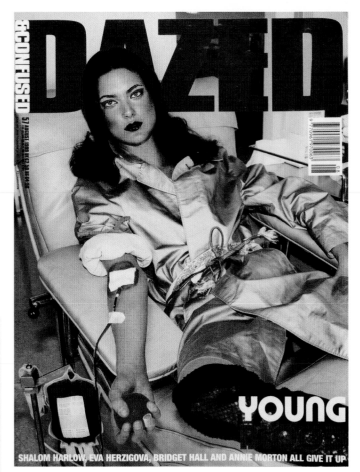

 1999 *Right:* Fashion photographer Terry Richardson's shot of model Shalom Harlow giving blood appeared on the cover of the August issue of *Dazed & Confused*. A self-consciously eccentric image for a style magazine, Richardson's work at that time shaped a taste against glamour.

2003 *Opposite above:* Unlike its English and American counterpart, Italian *Vogue* holds onto its cutting-edge status by eschewing the conventional signifiers of a women's magazine. This beautifully composed and printed gatefold cover employs a photograph by leading American fashion photographer Steven Meisel.

2001 *Above:* The cover of this issue of *Sleazenation* designed by Scott King might be read as aggressive comment on news-stand competition or even an attack on the reader.

2002 *Opposite below left:* Tim Ronan's elaborate portrait of rap star Snoop Dogg on the cover of American title *Flaunt* incorporates a share certificate with embossed decoration and copperplate lettering.

2000 *Opposite below right:* Launched in London in 1995 and in New York in 1998, *Trace* is a multicultural style title. This striking back-street portrait of Nigerian model Oluchi was taken by Patrick Ibanez.

THE STYLE PRESS TODAY

One of the most volatile sectors of publishing today is the style press. That independent magazines largely dealing with fashion and music are subject to dramatic swings of fortune is not surprising, given their self-appointed role as clairvoyants in the fickle world of style. The impact of these titles should not be measured in commercial terms alone. Many famous writers, photographers and illustrators have cut their teeth on their low-budget pages before achieving success in the mainstream. *Dazed & Confused*, the brainchild of fashion photographer Rankin Waddell, Ian Taylor, and writer Jefferson Hack, was first produced while at art college in London in 1991. Commentators have put the magazine's startling success down to its visual flair and its refusal to pander to what Hack called the "empty egos of the rich and famous". Conversely, the rest of the media uses the style press as a gauge of up-and-coming trends. The idea of a radical avant-garde in the world of style is, however, increasingly difficult to sustain as ostensibly mainstream titles like Italian *Vogue* seem almost indistinguishable from the new wave.

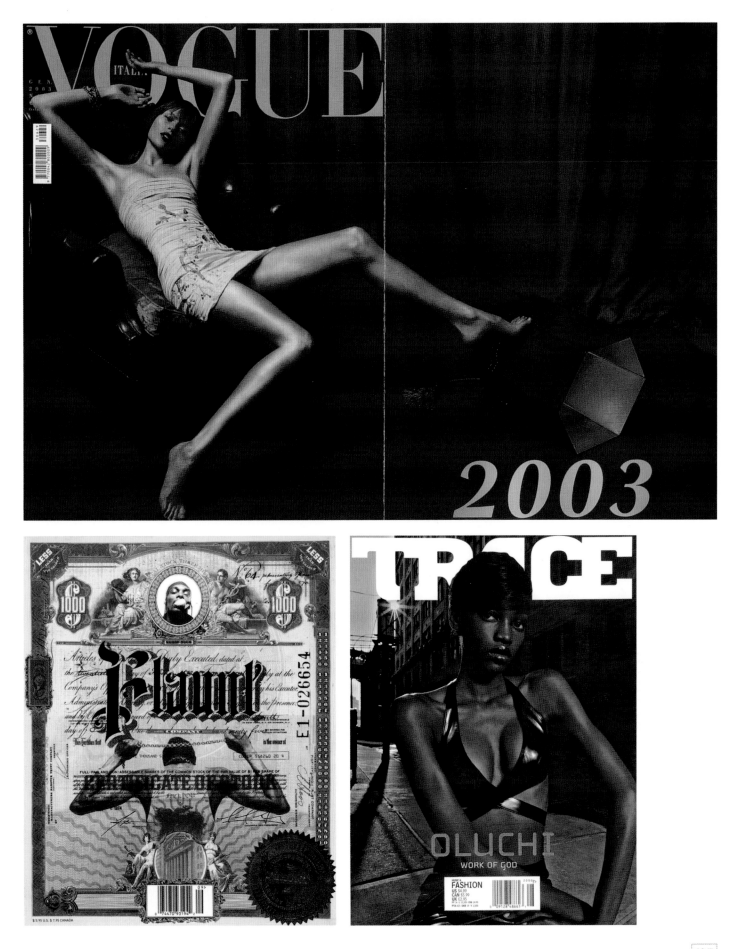

FURTHER READING

Andersson, Patrik, and Judith Steedman, *Inside Magazines: Independent Pop Culture Magazines*, Thames and Hudson, 2002.

Aperture, "The Idealizing Vision – the Art of Fashion Photography", 1991.

Arnold, Fritz, *One Hundred Caricatures from Simplicissimus, 1918–1933*, Goethe Institute, 1984.

Aynsley, Jeremy, *Graphic Design in Germany 1890–1945*, University of California Press, 2000.

Ballaster, Ros, et al., *Women's World: Ideology, Femininity and the Women's Magazine*, MacMillan, 1991.

Barson, Michael, and Steven Heller, *Teenage Confidential. An Illustrated History of the American Teen*, Chronicle Books, 1998.

Bauret, Gabriel, *Alexey Brodovitch*, Assouline, 1999.

Beetham, Margaret, and Kay Boardman, (eds), *Victorian Women's Magazines; An Anthology*, Manchester University Press, 2001.

Bierut, Michael, et al., *Looking Closer: Critical Writings on Graphic Design*, Allworth Press with the American Institute of Graphic Arts, 1995.

Bierut, Michael et al., *Looking Closer 2: Critical Writings on Graphic Design*, Allworth Press with the American Institute of Graphic Arts, 1997.

Bierut, Michael, et al., *Looking Closer 3: Critical Writings on Graphic Design*, Allworth Press, 1999.

Bierut, Michael, et al., *Looking Closer 4: Critical Writings on Graphic Design*, Allworth Press, 2002.

Blackwell, Lewis, *David Carson: 2ndsight. Grafik Design after the End of Print*, Laurence King, 1997.

Blackwell, Lewis, *The End of Print: The Graphic Design of David Carson*, Laurence King, 1995.

Broos, Kees, and Paul Hefting, *Dutch Graphic Design*, Phanes Press, 1993.

Buechner, Thomas S., *Norman Rockwell: Artist and Illustrator*, Harry N. Abrams, 1996.

Carter, Alice A., *The Art of National Geographic: A Century of Illustration*, National Geographic Society, 1999.

Claridge, Laura, *Norman Rockwell: A Life*, Modern Library, 2003.

Colegrave, Stephen, and Chris Sullivan, *Punk*, Cassell, 2001.

Cooper, J., *The Fashion Photographer and the Fashion Magazine in Britain, 1955–1985*, 1985.

Corey, Mary F., *The World Through a Monocle: The New Yorker at Midcentury*, Harvard University Press, 1999.

Dancyger, Irene, *A World of Women. An Illustrated History of Women's Magazines 1700-1970*, Gill and Macmillan, 1978.

Denver Art Museum, *Herbert Bayer. A Total Concept*, 1973.

Dewitz, Bodo von, and Robert Lebeck, *Kiosk: A History of Photojournalism*, Scalo, 2002.

Dickerman, Leah, (ed.), *Building the Collective: Soviet Graphic Design, 1917–1937*. Selections from the Merrill C. Berman Collection, Princeton Architectural Press, 1996.

Doss, Erika, *Looking at Life Magazine*, Smithsonian Books, 2001.

Driver, David, *The Art of Radio Times. The First Sixty Years*, BBC, 1981.

Duncombe, Stephen, *Notes from Underground. Zines and the Politics of Alternative Culture*, Verso, 1996.

Dyer, Richard, *Stars*, BFI Publishing, 1998.

Evans, David, *John Heartfield: AIZ Arbeiter-illustrierte Zeitung/Volks Illustrierte 1930–1938*, Kent, 1992.

Evans, David, and Sylvia Grohl, *Photomontage: A Political Weapon*, Fraser, 1986.

Fahey, David, and Linda King, *Masters of Starlight. Photographers in Hollywood*, Random House, 1990.

Fergusson, M., *Forever Feminine. Women's Magazines and the Cult of Femininity*, London 1985.

Fountain, Nigel, *Underground: The London Alternative Press 1966–1974*, 1988.

Gabler, Neal, *Life, the Movie: How Entertainment Conquered Reality*, Knopf, 1998.

Gruber Garvey, Ellen, *The Adman in the Parlor: Magazines and the Gendering of Consumer Culture, 1880s to 1910s*, Oxford University Press, 1996.

Giovannini, Joseph, et al., *Graphic Design in America: A Visual Language History*, Walker Art Center, Abrams, 1989.

Goldberg, Vicki, *The Power of Photography: How Photographs Changed Our Lives*, Abbeville Press, 1991.

Gough-Yates, Anna, *Understanding Women's Magazines*, Routledge, 2002.

Grundberg, Andy, *Brodovitch, Harry N.* Abrams, 1989.

Haining, Peter, *The Classic Era of the American Pulp Magazine*, Prion, 2000.

Haining, Peter, *Terror! A History of Horror Illustrations from the Pulp Magazines*, Souvenir Press, 1976.

Hall, Stuart, "*The Social Eye of Picture Post*" in *Working Papers in Cultural Studies*, no. 2, Spring 1972, pp. 71 -120.

Hall, Peter, and Michael Bierut, (eds.), *Tibor Kalman: Perverse Optimist*, Booth-Clibborn Editions, 1998.

Harrison, Martin, Appearances: *Fashion Photography since 1945*, Jonathan Cape, 1991.

Hebdige, Dick, *Hiding in the Light: On Images and Things*, Routledge, 1988.

Heller, Steven, *Cover Story: The Art of American Magazine Covers 1900–1950*, Chronicle Books, 1996

Heller, Steven, *German Modern: Graphic Design from Wilhelm to Weimar*, Chronicle Books, 1998

Heller, Steven, and Georgette Balance, (eds), *Graphic Design History*, Allworth, 2001.

Heller, Steven, *Magazines Inside & Out*, Nippan, 1996.

Heller, Steven, *Paul Rand*, Phaidon, 1998.

Henkel, David K., *Collectible Magazines: Identification and Price Guide*, HarperCollins, 2000.

Hermes, Joke, *Reading Women's Magazines*, Polity Press, 1994.

Hillman, David, and Harri Peccinotti, *Nova 1965–1975*, Pavilion, 1993.

Holmstrom, John, (ed.), *Punk: The Original. A Collection of Material from the First, Best, and Greatest Punk Zine of All Time*, High Times Press, 1998.

Hopkinson, Tom, *Picture Post 1938–1950*, Penguin, 1970.

James, David (ed.), *Inside Out. "Dazed and Confused"*, Booth-Clibborn Editions, 2000.

Jenkins, Janet (ed.), *In the Spirit of Fluxus*, Walker Art Center, 1993.

Jobling, Paul, and David Crowley, *Graphic Design. Reproduction and Representation since 1800*, Manchester University Press, 1996.

Jones, Terry, *Instant Design: A Manual of Graphic Techniques*, Architecture Design and Technology Press, 1990.

Jones, Terry, *Smile i-D: Fashion and Style*, Taschen, 2001.

Kalman, M., *Colors. Issues 1–13 – the Tibor Kalman Years*, Thames & Hudson, 2002.

Kellein, Thomas, *Fluxus*, Thames and Hudson, 1995.

Kinross, Robin, *Modern Typography. An Essay in Critical History*, Hyphen Press, 1992.

Kobal, John, *The Art of the Great Hollywood Portrait Photographers, 1925–1940*, Allen Lane, 1980.

Le Coultre, Martijn F., *Wendingen: A Journal for the Arts, 1918-1932*, Princeton Architectural Press, 2001.

Lesser, Robert, *Pulp Art. Original Cover Paintings for the Great American Pulp Magazines*, Gramercy Books, 1997.

Levin, Martin (ed.), *Hollywood and the Great Fan Magazines*, Arbor House, 1973.

Lloyd, Valerie, *The Art of Vogue Photographic Covers*, Octopus, 1986.

Livingston, Jane, *Odyssey: The Art of Photography at National Geographic*, Thomasson-Grant, 1988.

Maison Européenne de la Photographie, *Alexey Brodovitch, La Photographie mise en page*, 1998.

Margolin, Victor, *The Struggle for Utopia: Rodchenko, Lissitzky, Moholy-Nagy, 1917–1946*, University of Chicago Press, 1997.

McCracken, Ellen, *Decoding Women's Magazines from Mademoiselle to Ms Palgrave*, 1992.

McQuiston, Liz, *Graphic Agitation: Social and Political Graphics Since the 1960s*, Phaidon, 1993.

Mellor, David Alan, and Laurent Gervereau, (eds.), *The Sixties: Britain and France, 1962-1973 The Utopian Years*, Phillip Wilson, 1997.

Mellor, David Alan, *Germany: The New Photography 1927–33*, Arts Council of Great Britain, 1978.

Melly, George, *Revolt into Style. The Pop Arts in Britain*, Allen Lane, 1970.

Merrill, Hugh, *Esky: The Early Years at Esquire* , Rutgers University Press, 1995.

Moholy-Nagy, László, *Painting, Photography, Film*, Lund Humphries, 1969.

Morrisson, Mark S., *The Public Face of Modernism: Little Magazines, Audiences, and Reception, 1905–1920*, University of Wisconsin Press, 2000.

Mouly, Françoise, and Lawrence Weschler, *Covering "The New Yorker": Cutting-edge Covers from a Literary Institution*, Abbeville Press, 2001.

Mullen, Chris, and Philip Beard, *Fortune's America: The Visual Achievements of Fortune Magazine, 1930–1965*, University of East Anglia Library, 1985.

Nelson, Elizabeth, *The British Counter-culture 1966–1973: a Study of the Underground Press*, Macmillan, 1989.

Neville, Richard, *Hippie Hippie Shake: The Dreams, the Trips, the Trials, the Love-ins, the Screw Ups, the Sixties*, Bloomsbury, 1996.

Nixon, Sean, *Hard Looks: Masculinities, Spectatorship and Contemporary Consumption*, UCL Press, 1996.

Osgerby, Bill, *Playboys in Paradise. Masculinity, Youth and Leisure-style in Modern America*, Berg, 2001.

Owen, William, *Magazine Design*, Lawrence King, 1991.

Packer, William, *The Art of 'Vogue' Covers*, Octopus Books, 1980.

Palmer, Tony, *The Trials of OZ, Blond and Briggs*, 1971.

Pendergast, Tom, *Creating the Modern Man: American Magazines and Consumer Culture, 1900–1950*, University of Missouri Press, 2000

Perry, Mark, *Sniffin' Glue: The Catalogue of Chaos 1976–1977*, Faber Paperbacks, 2000.

Rand, Paul, *A Designer's Art*, Yale University Press, 1985.

Rand, Paul, *Thoughts on Design*, Wittenborn, 1947.

Robinson, Frank M., and Lawrence Davidson, *Pulp Culture: The Art of Fiction Magazines*, Collectors Press, 1998.

Rojek, Chris, *Celebrity*, Reaktion, 2001.

Rouard-Snowman, Margo, *Roman Cieslewicz. Master of Graphic Design*, Thames & Hudson, 1993.

Scanlon, Jennifer, *Inarticulate Longings: The Ladies' Home Journal, Gender, and the Promises of Consumer Culture*, Routledge, 1995.

Scotford, Martha, *Cipe Pineles. A Life in Design*, W.W. Norton & Company, 1999.

Seago, Alex, *Burning the Box of Beautiful Things. The Development of a Postmodern Sensibility*, Oxford University Press, 1995.

Soar, Geoffrey, and David Miller, *Interaction & Overlap: From the Little Magazine and Small Press Collection at University College London*, Workfortheeyetodo, 1994 .

Seebohm, Caroline, *The Man who was Vogue: The Life and Times of Condé Nast*, Weidenfeld and Nicolson, 1982.

Taylor, John, *War Photography. Realism in the British Press*, Routledge, 1991.

Taylor, John, *Body Horror. Photojournalism, Catastrophe and War*, Manchester University Press, 1998.

Teitelbaum, Matthew (ed.), *Montage and Modern Life, 1919–1942*, MIT Press 1992.

Twyman, Michael, *Printing 1770-1970 An Illustrated History of its Development and Uses*, Eyre & Spottiswoode, 1970.

Vanderlans, R., Z. Licko, and M. E. Gray, *Émigré. Graphic Design in the Digital Realm*, Van Nostrand Reinhold, 1993.

Wozencroft, Jon, *The Graphic Language of Neville Brody*, Thames & Hudson, 1987.

White, Cynthia, *The Women's Periodical Press in Britain 1945–76*, HMSO, 1977.

Whiteley, Nigel, *Pop Design: Modernism to Mod*, Design Council, 1987.

Winship, Janice, *Inside Women's Magazines*, Pandora, 1987.

Yagoda, Ben, *About Town: The New Yorker and the World It Made*, Da Capo Press, 2001.

INDEX

Illustrations are denoted by titles in italic

ACKNOWLEDGMENTS

The author would like to thank for their help and advice:
Juliet Ash, Paul Clark, Giulia Hetherington, Paul Jobling,
Andrew Kingham, Emily King, Joe Kerr, Pearce Marchbank,
Gillian Naylor, Lucy Neville, Bill Osgerby, Louise Tucker,
Dominic Sweeny, and Rudy Vanderlans.

Mitchell Beazley would like to thank all those who have
helped in the making of this book, including Roger Dixon
for photography. Additional credits and magazine publisher
acknowledgements appear below.

Key: a above, b below, l left, r right

AKG-Images: 17ar, 21; BBC Worldwide: 41; Bellerophon
Publications Inc, 2003: 32a; courtesy of Brant Publications, Inc:
112,113; Bridgeman Art Library: V&A Museum, London 16,
Historisches Museum der Stadt, Vienna 17al, Glasgow University
Library 17ar, Haags Gemeentemuseum 20r; Centaur
Communications Ltd: 30a; Colors Magazine: photo Stefano
Montesi/Franca Speranza 88a; photo Anthony Bolton 88b; photo
Attilio Vianello 89; Condé Nast (Italy): 137a; Condé Nast
Publications Ltd (UK): 120, Giorgio de Chirico/DACS 2003 121l;
Condé Nast Publications (US): 34, 46, 47, 86, 87, 124, 125;
Corbis: 38l; EMAP plc: 11a, 108, 109; Getty Images: Time 6; Life 10;
Life/NASA 56; Life/Henri Cartier Bresson 70; Life 71tl; Life/Philippe
Halsman 71tr; Life/Clarence Bull 71b; Life/Mark Kauffman 78tl;
Life/Henri Huet 78tr; Time/Norman Gorbaty 79; Hearst
Corporation: 9b, 122, 123, 126, 127, 130, 131; IPC Media: 32b, 104,
114; Johnson Publishing Company: 72, 73; David King Collection:
20, 64, 65; Meredith Corporation: 118, 119; The Mitchell Wolfson Jr
Collection, The Wolfsonian-Florida International University,
Miami Beach: 20l; courtesy National Geographic Society: 74bl,
Davis Meltzer 74br, Harris & Ewing 75tl, Lee Boltin, Metropolitan
Museum of Art 75tr, Des & Jen Bartlett 75bl, Joe McNally 75br;
Netherlands Architectural Institute, Rotterdam: © El
Lissitzky/DACS 2003 18Reed Business Information Ltd: 9a, 37a;
Rochester Institute of Technology, NY, Melbert B Cary Jr Graphic
Arts Collection: 22r ; Saturday Evening Post: Estate of Norman
Rockwell 44, 45; Stay Free!: 2001 Carrie McLaren 91r; Tate
Archive, London: 19l; Time Inc: 42, 43, 50l; Yale University Library,
New Haven, CT, courtesy Mrs Paul Rand :14.

We would also like to thank the following libraries for allowing
material in their collections to be photographed: Royal College of
Art, London: 15, 17ar, 19r, 26-7; University of Brighton: 28-9, 46-7.